Native Paths

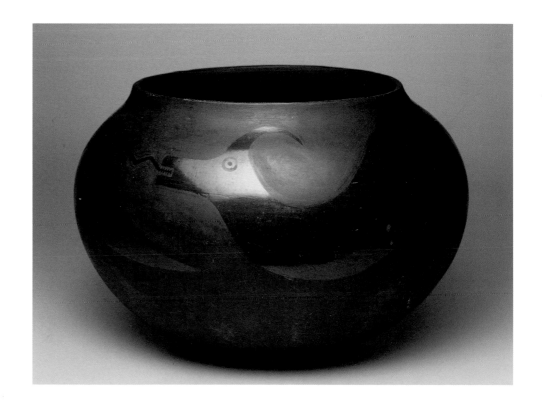

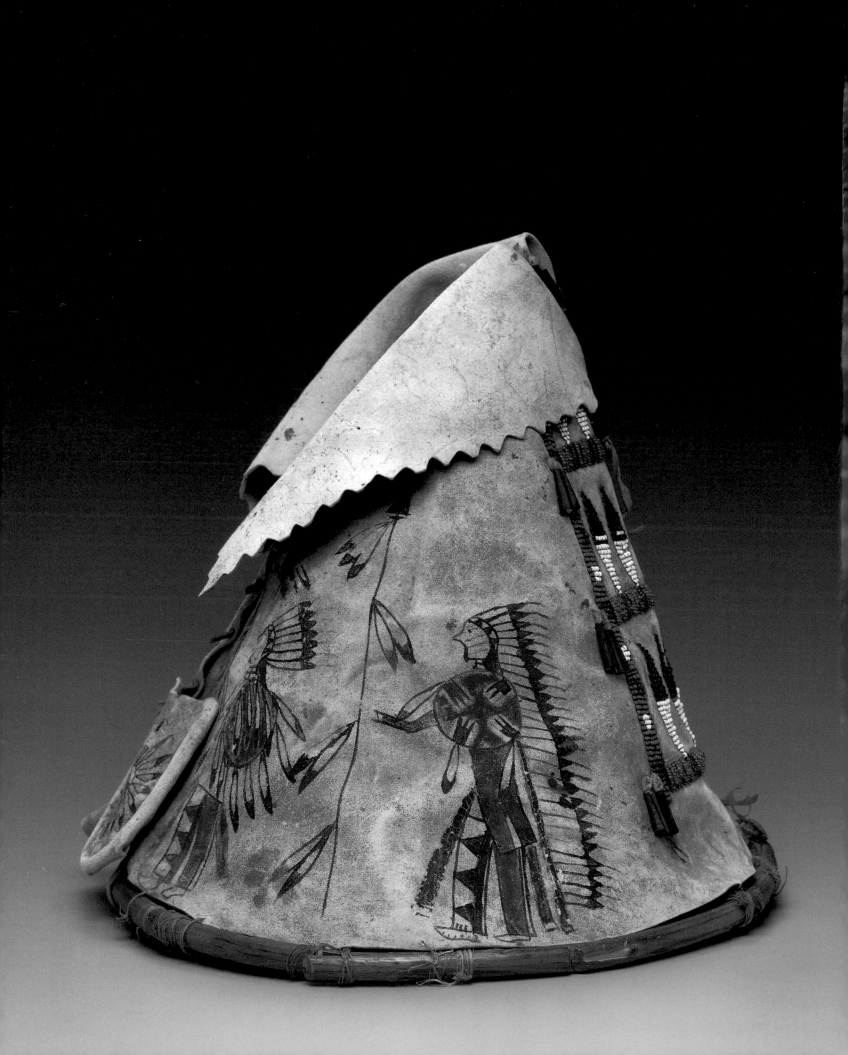

Native Paths

American Indian Art from the Collection of
Charles and Valerie Diker

Janet Catherine Berlo
Bruce Bernstein
T. J. Brasser
N. Scott Momaday
Allen Wardwell
W. Richard West

Edited by Allen Wardwell

The Metropolitan Museum of Art, New York

This publication is issued in conjunction with the exhibition "Native Paths:
American Indian Art from the Collection of Charles and Valerie Diker," held at
The Metropolitan Museum of Art,
New York, from May 7, 1998, to January 2, 2000.

Published by The Metropolitan Museum of Art, New York
Copyright © 1998 by The Metropolitan Museum of Art

John P. O'Neill, Editor in Chief
Barbara Burn, Executive Editor
Martina D'Alton, Editor
Michael Shroyer, Designer
Rich Bonk, Production

Photography by Dirk Bakker

Printed by Meridian Printing Company,
East Greenwich, Rhode Island

Native Paths: American Indian art from the collection of Charles and Valerie
Diker / Janet Catherine Berlo . . . [et al.]; edited by Allen Wardwell.
p. cm.
Catalog of an exhibition held at the Metropolitan Museum of Art,
May 7, 1998–Jan. 2, 2000.
Includes bibliographical references and index.
ISBN: 0–87099–856–0 (hc.); 0–87099–857–9 (pbk.: alk. paper)
1. Indian Art—North America—Exhibitions. 2. Diker, Charles—Art collections—
Exhibitions. 3. Diker, Valerie—Art collections—Exhibitions. I. Berlo, Janet
Catherine. II. Wardwell, Allen. III. Metropolitan Museum of Art (New York, N.Y.)
E98.A7N367 1998
704.03'97'00747471—dc21 98-13198
 CIP

Front cover: cat. no. 113. Gift basket, ca. 1850. Central California, Wappo or
Southern Pomo; sedge root, bulrush root on single-rod foundation;
clamshell and glass beads, quail topknot feathers.

Part-title page: cat. no. 97. María and Julian Martínez (1887–1980 and
1885–1943). Jar, 1919–20. Southwest, San Ildefonso Pueblo;
black-on-black ceramic.

Frontispiece: cat. no. 14. Toy tipi, 1880s. Central Plains, Teton Sioux;
native-tanned skin, pigment, glass beads, wood.

Contents

Foreword

It is a pleasure to present to the Metropolitan's public an exhibition of the art of Native North American peoples. Drawn from the collection of New Yorkers Charles and Valerie Diker, *Native Paths* covers broad spectrums—different times and places, different materials and functions, different peoples and traditions—that represent the cultural and artistic diversity characteristic of the Native peoples of this continent. Hundreds of Indian groups of diverse language, custom, and belief form the basis of this variation. Mirrored, too, within the treasured objects that these groups made to embellish their lives is the particular environment in which they lived.

The peoples of the forested Northeast and those of the majestically wooded Pacific Northwest fabricated and cherished objects made of wood; the peoples living in the open spaces of the Great Plains valued the horse to such an extent that the animal itself was decorated; the desert dwellers of the Southwest saw fit to embellish their water jars. When works such as these are exhibited here, American Indian art takes its place among the artistic heritage of the peoples of all continents.

It is thanks to the collecting commitment of the Dikers that *Native Paths* is taking place. Charles and Valerie Diker firmly believe in the aesthetic purport of Native American works—even though they will tell you that there is no word for "art" in any American Indian language—and they further believe not just in the importance of sharing the great American Indian works with others, but also in the importance of convincing others of that aesthetic message. They wish to make believers of all viewers, and to do so they are willing to lend their collection for an unusually long period of time, allowing for its display until the beginning of the next millennium.

The Diker Collection has come together over many years, but the pace of acquisition has recently increased as the Dikers' commitment to Native Americans and their art has increased. Famous artists' names appear among the collection's holdings, but there are, of course, many works for which the maker's name has not been recorded. The painted and beaded hides, for instance, made for a variety of purposes during the last decades of the nineteenth century in the Northern Plains—the same arts that are today virtually emblematic of the heroic American Indian—are without known author. Yet the robes, dresses, and shirts are evocative, insistent presences with an aura of myth that belies their functional purpose and engages all viewers.

I am particularly grateful to Richard West, the distinguished director of the National Museum of the American Indian, for understanding the value of exhibiting works of Native American art for art's sake and for recognizing the Metropolitan Museum as a suitable venue for that honor.

Philippe de Montebello
Director, The Metropolitan Museum of Art

Preface: An Expression of the Spirit

N. Scott Momaday

My father, who was a Kiowa and an artist in the tradition of "the Kiowa Five"—that group of watercolorists who determined in large measure the character of American Indian painting in the modern era—once said to me, "Art is above all an expression of the spirit; American Indian art expresses the spirit of the world in which we live and have lived for many thousands of years. In it there is a definition of the ancient and the sacred." I have never forgotten these words. In the equation of the ancient and the sacred, there is also the beautiful.

> May it be beautiful before me,
> May it be beautiful behind me,
> May it be beautiful below me,
> May it be beautiful above me.
> May it be beautiful all around me.
> In beauty it is finished.

These words, from a prayer of the Navajo Night Chant, comprehend the essence of American Indian art. They formulate the simple and profound conviction that the earth and sky, the mountains and rivers, the animals with whom we share the gift of life, are beautiful. The artist is concerned to translate, wholly and truly, the beauty of the world he perceives to the reflection he creates. His vision images all the glories of the universe; his hand is the instrument of Creation. It is a great and holy enterprise.

In this superb collection of American Indian works of art, shown in one of the great museums of the world, the Native American may feel secure in his genius, dignified in his person, and celebrated in his spirit. This is more than an exhibition of great moment; it is the recognition and realization of the beautiful as it informs a tradition that permeates time and place.

Charles and Valerie Diker have been closely associated with American Indian culture for many years, and they have a deep understanding of and appreciation for American Indian art. They are among the great collectors of art in our time, and they have very generously shared their collections with others. In this instance they enable us to see into the very heart of an aesthetic that is an intrinsic part of our national experience by permission, our treasure, and our definition as Americans and members of the Family of Man. Let us look, celebrate, and be glad.

Introduction

W. Richard West

As director of the National Museum of the American Indian, I have always believed that a collection, at its best, reflects the special gifts and sensibilities of its collectors—and the collection of Charles and Valerie Diker speaks eloquently to this point. I have had the great personal pleasure of knowing Charles and Valerie in many different lives. They have served, with high distinction and deep commitment, as the co-chairs of the board of directors of the National Museum of the American Indian's George Gustav Heye Center in New York City. In doing so they have played a pivotal role in creating an international institution of living Native cultures at the Smithsonian Institution that will serve as the home of the world-renowned George Gustav Heye Collection.

I also know Charles and Valerie well as collectors whom I, as a museum director and as an American Indian myself, deeply respect and greatly value for many reasons. Over a period that now stretches to almost a generation, they have brought to their collecting a vision and sensibility that make their collection genuinely remarkable; it is a rare pleasure and privilege to behold. Each time I visit their homes in New York or New Mexico, I am always delighted to witness, through their acquisition of an exciting and beautiful new object, the depth and ever-expanding scope of their collection. Just as contemporary Native peoples continue to believe that these objects live and breathe, so the Diker Collection takes on an organic nature of its own, constantly broadening, deepening, and stretching to encompass new materials, new cultural areas, and new artistic traditions.

In all of this growth and expansion, however, Charles and Valerie maintain several vital constants as collectors of American Indian art. They and their collection have immense discipline and, as a consequence, represent the very best in the long and distinguished tradition of art collecting and connoisseurship. They bring to their collecting a thorough and scholarly knowledge of what they collect and, more particularly, an insightful and sensitive understanding of the very different cultural context in which the American Indian art tradition has developed. Perhaps most important to the presence of the Diker Collection at The Metropolitan Museum of Art, Charles and Valerie possess an unfailingly accurate appreciation of the compelling aesthetics of much of the material that was created by this hemisphere's first peoples.

As director of the National Museum, I have a vital stake in this final attribute of the Diker Collection and in the collecting approach of Charles and Valerie. For far too long the artistic traditions of American Indians have sat apart from the art museums of this nation and have been viewed almost strictly in terms of anthropology and solely as ethnography. Charles and Valerie Diker recognize this exclu-

sion as error and, through their collection, have demonstrated what many have known to be true: objects created by American Indians constitute a body of remarkable art by any aesthetic measure.

I shall always be grateful to Charles and Valerie Diker for their committed and elegant pursuit of this baseline principle of American art. I know that they are honored to have their collection at The Metropolitan Museum of Art, and I believe this most distinguished of American art museums should be equally honored to host the Diker Collection.

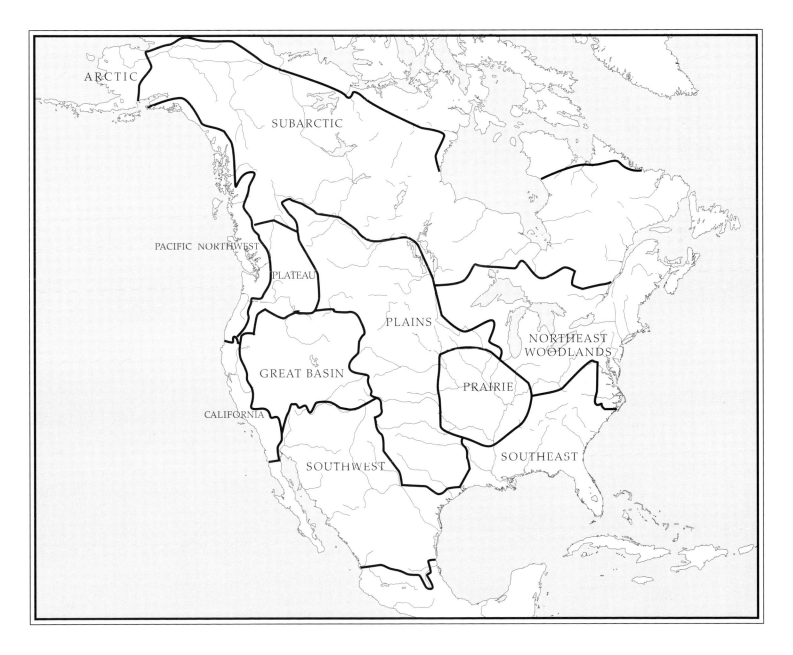

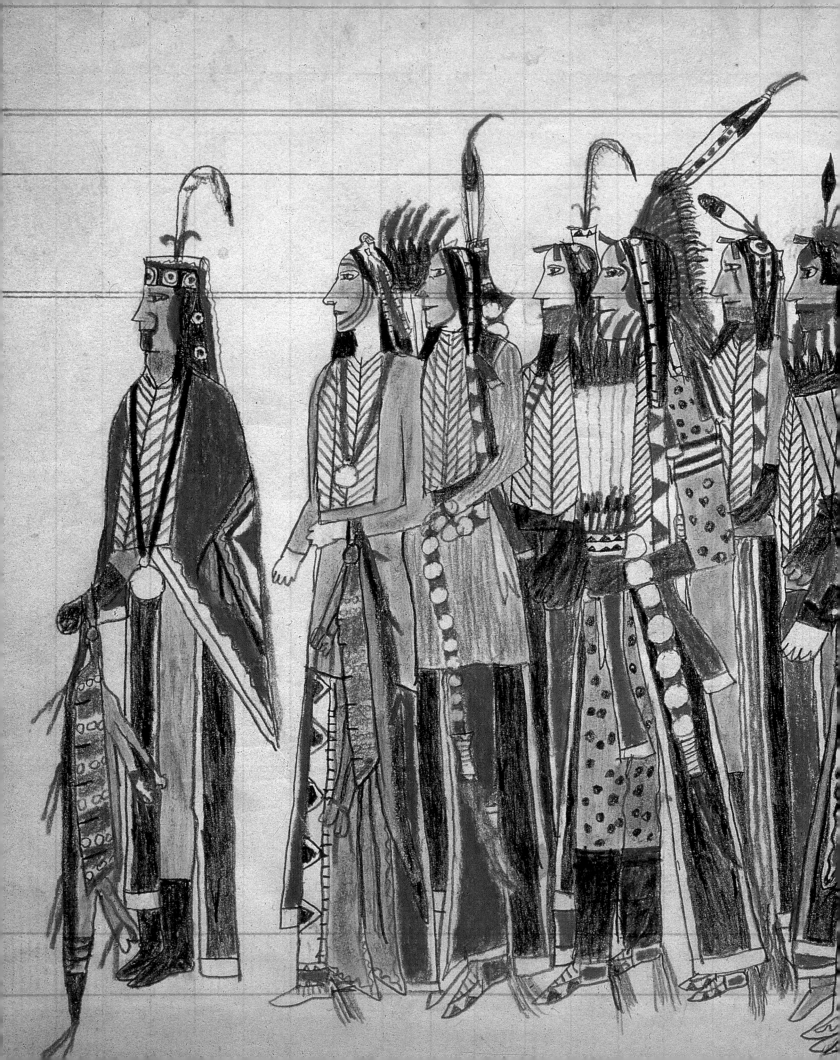

Arts of Memory and Spiritual Vision: Plains Indian Drawing Books

Janet Catherine Berlo

From 1846 to 1852 a Swiss artist named Rudolf Kurz lived among the Indians of the Upper Missouri River. In his diary he recorded the keen interest with which male artists of the Mandan, Lakota, and other tribes scrutinized his paintings. Yet in some cases, Kurz wrote, the indigenous artist was more intent on presenting his own work: "While I was sketching this afternoon the Sioux visited me. He brought two interesting drawings. He was not satisfied with my work; he could do better. Forthwith I supplied him with drawing paper."

Kurz goes on to say: "In their drawings Indians attempt to make especially prominent some outstanding distinguishing feature. For instance, in drawing the figure of a man they stress not his form but something distinctive in his dress that indicates his rank; hence they represent the human form with far less accuracy than they draw animals. Among the Indians, their manner of representing the form of man has remained so much the same for thousands of years that they look upon their accepted form as historically sacrosanct, much as we regard drawings in heraldry. We must take into consideration, moreover, that the human form is not represented in the same manner by all nations; on the contrary, each nation has its own conventional manner."

The "conventional manner" for representing the human form mentioned by Kurz was in a process of change on the Great Plains in the nineteenth century. The indigenous style, as seen in early hide paintings and rock art, evinced little interest in detailed depictions of clothing and paraphernalia. By the last three decades of the nineteenth century, however, when thousands of drawings on paper were being produced by male warrior-artists of the Lakota, Cheyenne, Kiowa, and other tribes of the Great Plains, this style had evolved into something new: an elegant graphic tradition in which pictorial autobiography, tribal history, and visionary experience were all represented in meticulously detailed works of art. These were drawn on scrap paper, on fine drawing sheets, and in discarded ledgers from traders and soldiers.

Some of these artworks retained aspects of the precontact drawing style. The Lakota artist Swift Dog (ca. 1845–1925), for example, may have been working in the 1880s when he drew with a free, confident, linear style the horse and rider (cat. no. 5). Yet his work recalls that of earlier generations of hide painters. The rider is drawn over his horse in a transparent "X-ray vision" style. In contrast, another Lakota artist, Short Bull (ca. 1847–ca. 1935), was careful to delineate depth and the illusionistic overlapping of the mounted rider and other figures in

his drawing of an encounter with three Pawnee (cat. no. 6). In another drawing he experiments even further with an extremely expressive contrapposto of falling horse and rider in depicting the wounding of a horse by Crow adversaries (cat. no. 7).

In these and many other cases, the names and some biographical data on the artists are known. In other instances, their work is the only remnant of their considerable individuality. Drawings from the Julian Scott Ledger (named for its collector, not its artist) reveal the work of several distinctive hands (cat. nos. 1, 2, 3). This is not unusual; men often drew in each other's memory books, recounting events from their own lives as warriors or from the tribal history of the group.

The artist I have designated as "Julian Scott Ledger Artist A" drew most of the works in the book in a vigorous, direct, untutored style. His scene of Caddos dancing (cat. no. 3) and of Kiowa women wearing the war paraphernalia of their husbands in a Victory Dance (cat. no. 2) are lively, colorful depictions of the Plains peoples' public dance performances. Julian Scott Ledger Artist B renders noses, eyes, hands, moccasins, and feathers in a slightly different manner (cat. no. 1). Both artists evince a keen interest in visually recording all the details of fancy dress, both traditional and modern. Feathered headdresses and split-horn war bonnets, bone necklaces and feathered fans, women's high buckskin leggings— all are carefully rendered to give the viewer the most detailed information about their construction and function. So, too, both artists reveal their delight in all of the trade goods that made nineteenth-century Plains ceremonial dress such a visual display: blue and red wool trade blankets with white selvages, German silver medallions, striped shawls and dotted calicoes, leather shoes and elegant top hats.

As the Plains graphic art tradition expanded in the 1870s and 1880s, it came to include complex ceremonial and historical scenes peopled with many figures. Sometimes a landscape setting or an architectural setting frames or locates the action. In one such ambitious scene (cat. no. 4), the artist (who was himself probably Cheyenne or Kiowa, to judge by the style of the work) depicts a Pawnee village on a ceremonial day. More than ten dozen people are shown. These range from the carefully arranged rows of parading Pawnee warriors on the right to the numerous onlookers, male and female, who fill the left side of the page. Some appear only as human heads popping up behind huge earth lodges, which were the characteristic architectural form of these Central Plains people (an architectural form that must have been of interest to the artist, himself a tipi-dweller).

This drawing may have been the left side of an even more ambitious two-page composition. It appears to represent the Pawnee Harvest Ceremony commemorating both the Sacred Corn and the Sacred Buffalo. A cornstalk altar with ears attached and a buffalo-skull altar have a prominent place in the center of the composition.

In addition to the numerous portrayals of ceremonial activities, dances, tribal encampments, scenes of valor in warfare, and historical events, a small number of artists strove to portray the ineffable in their drawings. One of the most powerfully expressive works in the entire oeuvre of late-nineteenth-century Plains drawings is the medicine vision from the Frank Henderson Ledger Book

(cat. no. 12). Working across two pages of a lined account book, the artist has depicted, in the lower left, a man struck down by an intense vision of a Medicine Being. In the upper right the Medicine Being appears in anthropomorphic form. Lines of power radiate from his eyes, hands, and feet. A hawk or eagle appears at his side and he rides a hail-spotted Thunder Horse. This powerful spirit offers to the prostrate man a painted shield spotted with hail and depicting an eagle head. This will serve as the warrior's insignia, protecting him in battle and proclaiming his profound connection with the mysterious forces of the universe.

In the upper left quadrant of the composition the artist has meticulously depicted the split-horn feather headdress of a high-ranking chief, a painted tipi, and a feathered war lance. The bottom half of the tipi is painted yellow with eagle and otter emblems. Above, another eagle with outstretched wings and claws is painted upon a red background emblazoned with numerous other eagle claws. Perhaps these are part of the vision as well, illustrating that proper use of the medicine power offered by the spirit being will result in great war honors—for only a man with many military successes to his name would have the right to own such a lance and headdress.

During the late nineteenth century, Plains men, often deprived of tradition-al artistic and ceremonial venues (because of their confinement to reservations, the outlawing of the Sun Dance, and the demise of the buffalo), turned to draw-ing in small books as a way to make sense of the profound cultural stress to which they were subjected. The eloquent results of their explorations with paper and pencil can be seen in the Diker Collection. Today, scholars study these draw-ings to understand the tumultuous events of the late nineteenth century, as por-trayed by the Native historians who visually recorded all aspects of their culture, both the traditional ways that were eroding and the new ways of life that were making dramatic inroads on the Great Plains. Moreover, many contemporary Native artists turn to these drawings with intense respect and admiration, seeing in the work of their ancestors the first experiments in a modern way of making Native art.

Note to the reader: Height precedes width in the dimensions unless otherwise specified.

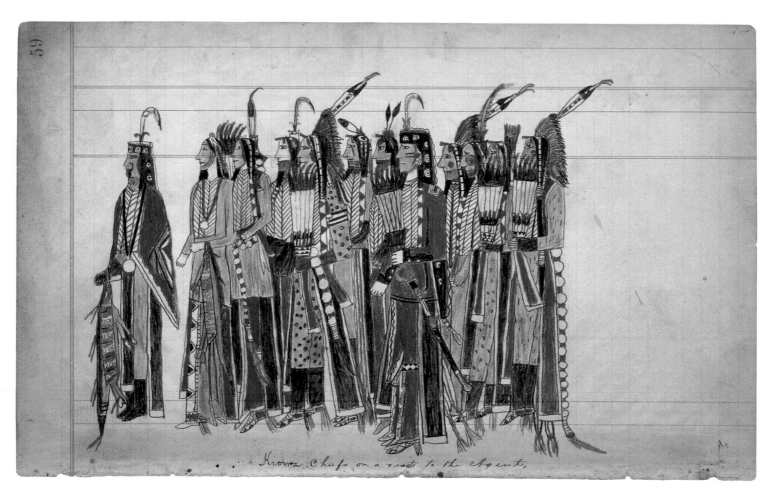

Kiowa Chiefs on a visit to the Agent,

Julian Scott Ledger Artist B
Southern Plains, Kiowa, dates unknown

1. **Twelve High-Ranking Kiowa Men, 1880**

Pencil, colored pencil, ink on paper;
7½ × 12 in. (19.1 × 30.5 cm)
Published: Berlo 1996, cat. no. 78;
McCoy 1987, pl. 31
Ex coll.: Julian Scott Ledger, no. 59;
ledger owned by Julian Scott, ca. 1890

Julian Scott Ledger Artist A
Southern Plains, Kiowa, dates unknown

2. **Women Wearing War Paraphernalia in Victory Dance, 1880**

Pencil, colored pencil, ink on paper;
8 × 12¼ in. (20.3 × 31.1 cm)
Published: McCoy 1987, pl. 25
Ex coll.: Julian Scott Ledger, no. 47;
ledger owned by Julian Scott, ca. 1890;
Mark Lansburgh, Santa Fe, N.M.

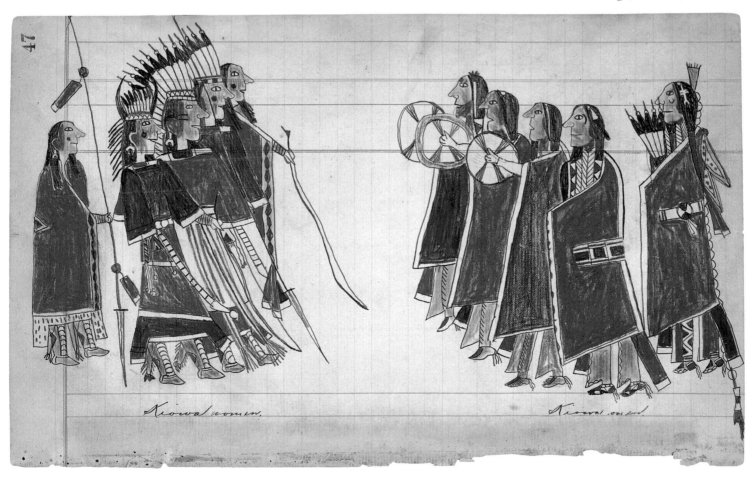

Julian Scott Ledger Artist A
Southern Plains, Kiowa, dates unknown

3. **Caddos, 1880**

Pencil, colored pencil, ink on paper;
7½ × 12 in. (19.1 × 30.5 cm)
Published: Berlo 1996, cat. no. 77;
McCoy 1987, pl. 28
Ex coll.: Julian Scott Ledger, no. 53;
ledger owned by Julian Scott, ca. 1890;
Mark Lansburgh, Santa Fe, N.M.

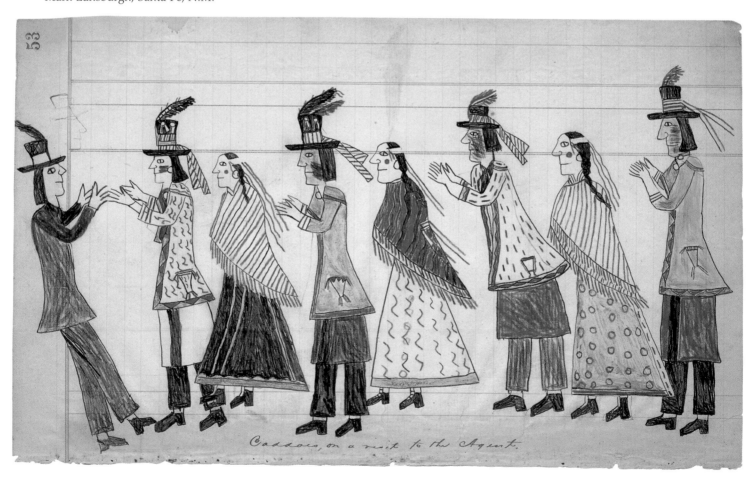

Caddos, on a visit to the Agent.

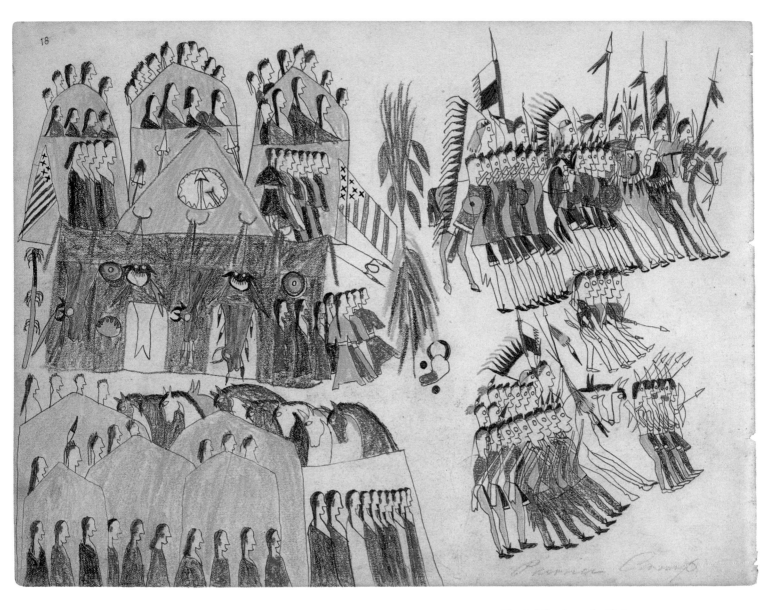

Fort Marion Artist

Southern Plains, Kiowa or Cheyenne, dates
unknown

4. **Fort Sill (Pawnee Village), 1875–78**

Pencil, colored pencil, ink on paper;
8½ × 11¼ in. (21.8 × 28.6 cm)

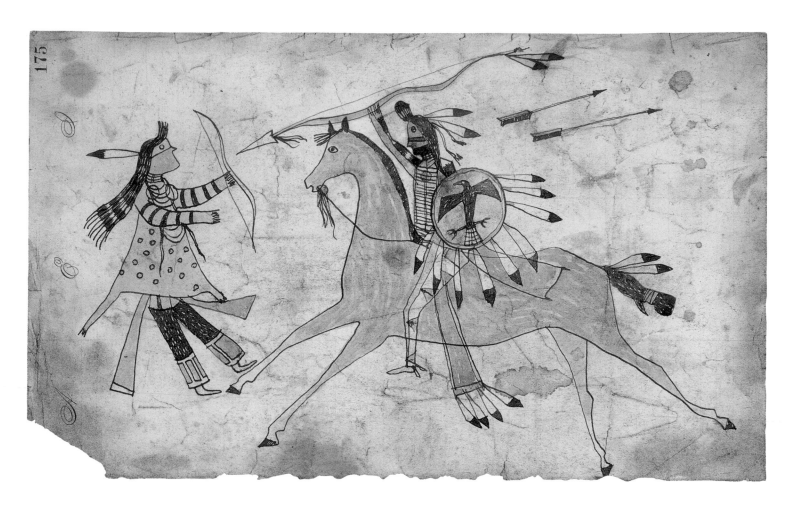

Swift Dog

Central Plains, Teton Sioux (Hunkpapa Lakota),
1845?–1925

5. **No Two Horns Fights a Crow, 1880s**

Watercolor, ink on paper; 7½ × 12 in.
(19.1 × 30.5 cm)
Published: Berlo 1996, cat. no. 149; McCoy
1994, p. 69, fig. 2
Ex coll.: Mark Lansburgh, Santa Fe, N.M.

Short Bull

Central Plains, Teton Sioux (Brulé Lakota),
1847?–?1935

6. **Short Bull Confronting Pawnees, 1890s (?)**

Watercolor, ink on paper; 7⅞ × 10 in.
(19.5 × 25.3 cm)
Published: Sotheby's (New York), December
2, 1987, lot 141 (23)
Ex coll.: Said to have been given by Short
Bull to Natalie Curtis of Santa Fe, N.M.,
folklorist and musicologist, ca. 1906; Paul
Burlin, Santa Fe, N.M., 1922; Mark
Lansburgh, Santa Fe, N.M.

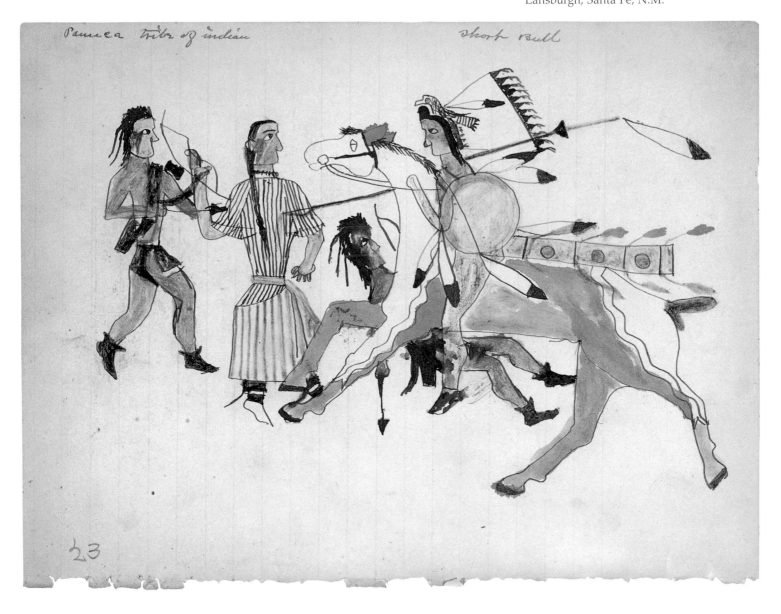

Short Bull

Central Plains, Teton Sioux (Brulé Lakota), 1847?–?1935

7. **Short Bull Falls from Wounded Horse, 1890s (?)**

Watercolor, ink on paper; 7 × 10 in. (17.8 × 25.4 cm)
Published: Maurer 1992, fig. 186; McCoy 1992, p. 59, fig. 6
Ex coll.: Said to have been given by Short Bull to Natalie Curtis of Santa Fe, N.M., folklorist and musicologist, ca. 1906; Paul Burlin, Santa Fe, N.M., 1922; Mark Lansburgh, Santa Fe, N.M.

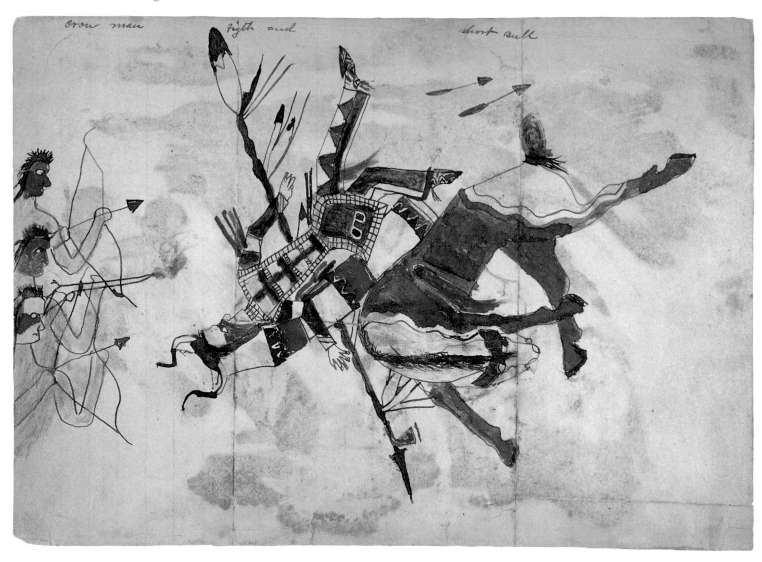

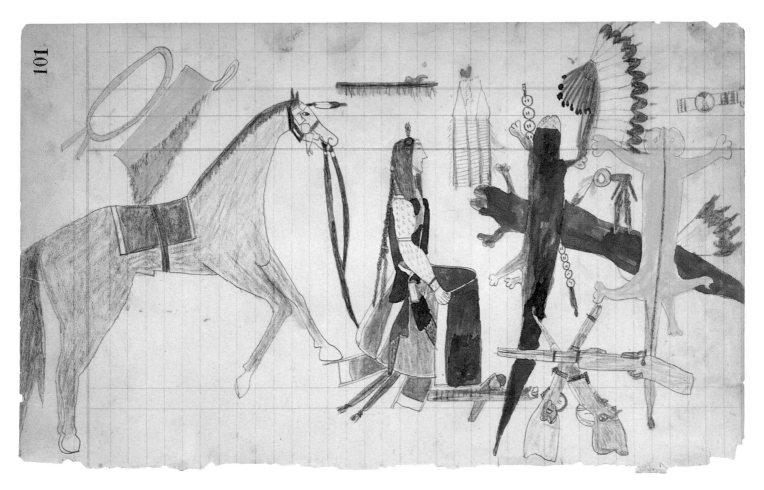

Old White Woman Ledger Artist (?)

Central Plains, Cheyenne, dates unknown

8. Indian, Horse, Pelts, and Rifles, 1870–85 (?)

Pencil, colored pencil, watercolor, ink on
paper; 7¼ × 11⅞ in. (18.4 × 30 cm)
Ex coll.: Possibly Old White Woman Ledger,
no. 101; Mark Lansburgh, Santa Fe, N.M.

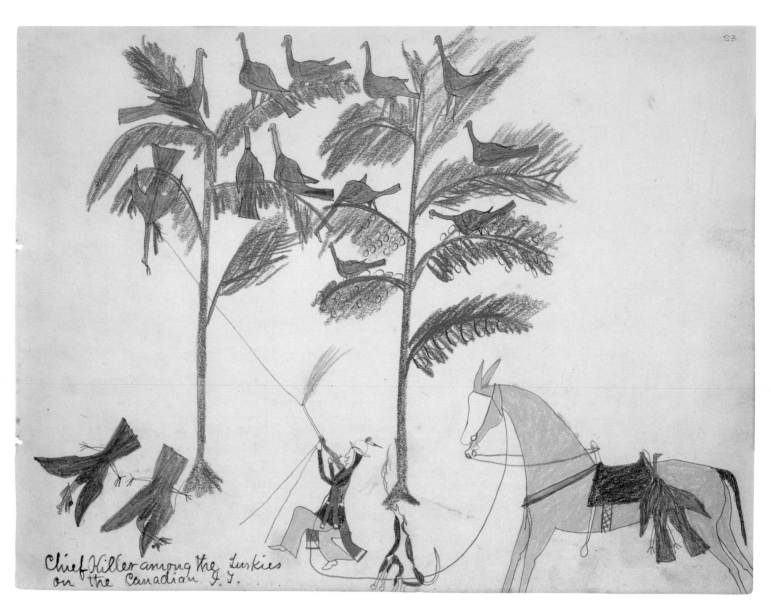

Chief Killer among the Turkies
on the Canadian I.T.

Chief Killer

Central Plains, Cheyenne, 1849–1922

9. **Chief Killer at a Turkey Shoot, 1876–78 (?)**

Pencil, colored pencil, ink on paper; 8⅝ ×
11¼ in. (22 × 28.6 cm)
Ex coll.: Mark Lansburgh, Santa Fe, N.M.

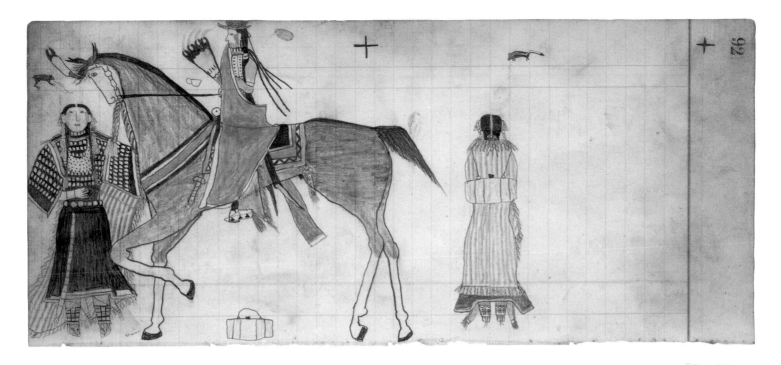

Henderson Ledger Artist B

Central Plains, Arapaho, dates unknown

10. **Man and Two Women, 1882**

Pencil, colored pencil, ink on paper; 5⅜ × 12 in. (13.5 × 30.5 cm)
Published: Berlo 1996, cat. no. 10; Peterson 1988, pl. 92
Ex coll.: Henderson Ledger, no. 92; ledger given by Frank Henderson to Martha Underwood of Carlisle, Pa., in 1882; Josephine Underwood Ritter

Henderson Ledger Artist A (perhaps Frank Henderson)

Central Plains, Arapaho, 1862–1885

11. **Horse and Rider, 1882**

Pencil, colored pencil, watercolor, ink on paper; 5⅜ × 12 in. (13.5 × 30.5 cm)
Published: Berlo 1996, cat. no. 8; Peterson 1988, pl. 120
Ex coll.: Henderson Ledger, no. 120; ledger given by Frank Henderson to Martha Underwood of Carlisle, Pa., in 1882; Josephine Underwood Ritter

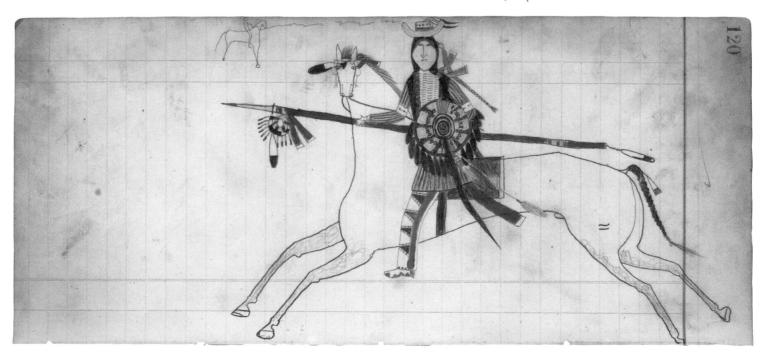

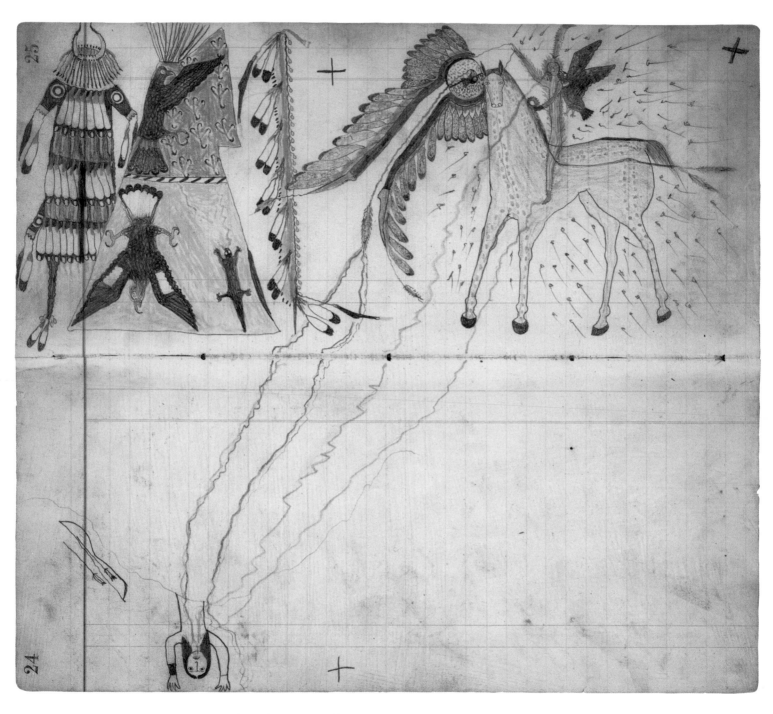

Henderson Ledger Artist A
(perhaps Frank Henderson)

Central Plains, Arapaho, 1862–1885

12. **Medicine Vision, 1882**

Pencil, colored pencil, ink on paper; 10⅝ × 11⅞ in.
(27 × 30 cm)
Published: Berlo 1996, cat. no. 9; Peterson 1988,
pl. 24–25
Ex coll.: Henderson Ledger, no. 24–25; ledger given
by Frank Henderson to Martha Underwood of
Carlisle, Pa., in 1882; Josephine Underwood Ritter

Blessed with Beauty: Quillwork and Beadwork of Plains and Woodland Indians

T. J. Brasser

The beautiful examples of North American Indian art acquired by Charles and Valerie Diker enable us to observe some of the major aspects of this work: the skills involved in its creation, the messages conveyed, the regional diversity, the changes inherent in any living art, and the complex impact of Euro-American civilization.

Native American languages may not have a word for art, but Native people knew when their artists had succeeded in giving visual expression to values and ideas dear to them. Not restricted to exceptionally gifted individuals, artistic creativity was an integral part of regular household tasks. Specific arts and crafts were assigned to either men or women, a division that was usually related to the conventional domains of each gender's social and economic responsibilities.

Much of this artwork was applied art, exploring a regional or tribal style in the design or decoration of utilitarian objects. In such a social context artists and artisans may not occupy an exalted position, but their creations enriched the daily experience of life. Beautiful things made for friends and relatives were believed to bless them with health and prosperity. Moreover, this creativity served the community by promoting the solidarity of its members and defining tribal identity vis-à-vis other peoples.

The Yellowstone River, Blue Earth county in Minnesota, Red Rock, and countless other locations on this continent derived their Native name, which survives in our renaming of the land, from a colored pigment found there. Pigments used for paint were mostly of mineral origin (vegetable ingredients were more important as a source for the dyes used in coloring porcupine quills and fibers). From the gathering of pigments to the final artwork, the process of painting was surrounded by ritual observations. The colors themselves had symbolic connotations, which were different in every region, relating to the major wind directions and the spirits residing there.

The basic techniques of skin-painting in the eastern Woodlands and the Plains were the same. Traditional Native American paintings are actually colored drawings, in which the colors were applied as a flat monochrome wash. Most of this painting was done with a bone or wooden stylus; fork-shaped markers were used in drawing bands of parallel lines on skin garments in the northeastern Woodlands. The pigments were prepared by dissolving them in hot water, if they

were to be used in painting on rawhide containers, or by mixing them with an adhesive, if they were for painting of skin garments. Boiled hide scrapings, fish roe, or cactus juice made a good binder; used by itself such colorless, clear sizing shows up as white outlines of geometric designs on older and well-used buffalo robes.

Male artists painted in a pictographic, representational style that was also used in painting and scratching pictures on regional rock formations. Some of these paintings related to the visionary experiences of the artist. This type is represented in the Diker Collection by a Western Apache painting of mountain spirits surrounded by images of sun, moon, stars, and the Water Monster of Apache mythology (cat. no. 15). Imbued with sacred power, this painted skin was worn by a medicine man in ceremonials, laid on his patients during curing rituals, and addressed in prayer as a living being.

Pictographic paintings made by men were frequently of a biographical nature, relating to their adventures in warfare. Painted on their skin garments and tipis, these pictures were intended as a record of exploits from which the warrior derived his prestige. After 1830 an increasingly realistic, detailed, and multicolored style developed in the Central Plains, presumably as a result of contacts with itinerant White artists. Representative of this style are the paintings on two models of Sioux tipi covers in the collection (cat. nos. 13, 14). In the late nineteenth century this stylistic development provided a background to the evolution of the so-called ledger art.

Abstract, geometric designs were painted mostly by women on their own skin dresses, on buffalo robes, rawhide containers, and tipi linings. Early examples indicate the wide spread of this style east of the Rocky Mountains, though it is best known from its survival in the northeastern and western margins of its former distribution.

In the geometric designs painted on buffalo robes of the Plains Indians, five basic patterns are recognized. The "Border and Box" design was most popular among the Western Sioux, though a distinct version of this design was used by Arapaho women. A girl's robe in this Arapaho style is one of the outstanding objects in the Diker Collection (cat. no. 16). Explicit statements by Native people indicate the symbolic quality of this painting, interpreted as a cosmogram focused upon the buffalo and the earth as symbols of life and prosperity.

This geometric style of the Plains Indians was related to the compositions of triangles, parallel straight and/or zigzag lines painted by the Native women in the northeastern Woodlands. These rigidly geometric designs were painted on the caribou skin garments of their men to make them more beautiful when hunting. It was believed that the paintings pleased the game spirits, who revealed the designs to the hunter in his dreams. The hunter's wife adjusted the dream-pictures to the regional art style. It was magical art, fostering the benevolence of the spiritual rulers of nature.

Exposed to the European tailoring of clothing and to French-Canadian folk art, the Native people of northern Québec and Labrador developed a distinctly curvilinear art style in the French colonial era. Most of the surviving skin coats painted in this style were made in the nineteenth century (cat. no. 25).

The use of porcupine quills in an intricate form of art was a unique development in the northern regions of aboriginal North America. Quillwork may well have originated as a local adaptation of hair embroidery, which itself is a circumboreal art form, possibly deriving from ancient Chinese silk embroidery. Porcupine quillwork was not restricted to the animal's northern habitat; its quills were obtained in trade by Indians throughout the Midwest and the Central Plains.

The quills were dyed by boiling them with plant pulp until the desired color was obtained. Red, black, yellow, and blue pigments were extracted from roots, berries, bark, and mosses, their selection depending on the regional flora. Lacking a good black dye, Plains Indians often used the dark stems of maidenhair fern as a substitute. Several travel accounts mention the extraction of dyes from boiled pieces of old red or blue blankets obtained from fur traders. Over time these bright colors faded, creating the appealing pastels of older quillwork; wherever it is possible to see the underside of the quills the original bright hues are visible.

Quillwork artists were always women. They made their designs by weaving or using some form of appliqué, which was stitched onto the buckskin with strong sinew thread. In either case the artist first flattened the quills by pulling them between her teeth. The most common appliqué techniques were wrapping, sewing, and plaiting. In the Great Lakes region leather strips were wrapped in pairs with the flattened quills to create a tight netlike effect, as in the strap of a pouch (cat. no. 29). The Crow Indians wrapped quills around hanks of horsehair, creating decorative strips and coiled rosettes on their garments (cat. no. 19). In plaiting, the quill was bent in a zigzag fashion back and forth around two parallel lines of stitching (cat. no. 37). Fine lines were made by wrapping the quill tightly around a single running stitch. This single-thread sewing lent itself to the curvilinear designs of the Lower Great Lakes region, where this type of quillwork technique was most common (cat. no. 36). Quill-weaving, which was most popular north of the Great Lakes, was done on a bow loom that held the warp threads taut. Quills were placed between the warp threads, and the weft thread passed alternately over and under the quills (cat. no. 28).

Quillwork designs were "owned" by the individual artists, who had received them "in their dreams" and who passed them on to their daughters. This practice was undoubtedly a factor in the development of specific tribal art styles. A curvilinear, semifloral style emerged by 1830 among the Métis, who were of mixed Native American and White ancestry and were concentrated along the Missouri and Red Rivers of the north. Elaborately quillworked costumes were produced by these people for sale to the Indians, White travelers, and mountain men (cat. no. 24). This Métis art style made its impact on the art of practically every tribe of the Northern Plains, the Plateau, and the Northwest Territories.

The introduction of glass beads by the fur traders made an enormous impact on Indian decorative art, particularly where imported cloth fabrics superseded the use of buckskin. Cloth fabrics did not lend themselves to painting or quillwork, but they provided an ideal material for bead embroidery.

The trade between Europeans and the Native people started along the coasts, where the use of Indian-made shell beads facilitated the adoption of imported glass beads. Having acquired this beachhead only a steady supply of European-made beads was needed to stimulate their adoption in the arts of more remote tribes. The women adapted their old quilling techniques to beadwork and developed some new techniques as well. The successful adaptation of traditional designs to beadwork promoted the continuation of regional art traditions. Beadwork is not always given its deserved admiration, yet it is the creativity in the selective assimilation of foreign influences by which the Native American population has managed to preserve its distinct identity.

Initially available only in small amounts, fairly large "pony beads" were used to create the open curvilinear designs of the northeastern Woodlands and to serve as narrow borders around quillwork. Beadwork remained a decorative medium of secondary importance until the nineteenth century, when thin steel needles and small "seed beads" became available in large quantities and a range of colors. At the same time, floral forms from American folk art became popular among Indian beadworkers in the Great Lakes region.

The continuation of old tribal art traditions is represented in the Diker Collection by examples from several regions. Scrolls as used in Choctaw beadwork derived from similar designs on late prehistoric ceramics of the Lower Mississippi (cat. no. 26). Lacelike patterns painted by Indians in the sixteenth-century Maritime Provinces continued in Micmac beadwork (cat. nos. 51, 52). Crow Indian beadwork designs were related to their geometric paintings on rawhide containers (cat. nos. 17, 18).

In the historic development of the equestrian Plains Indian culture the trend-setting centers of artistic creativity moved from the sedentary tribes on the Missouri River to the nomads of the High Plains, particularly the Western Sioux, Cheyenne, Crow, and Blackfeet. From these tribes unifying influences reached in all directions. Cheyenne and Arapaho designs served as prototypes in the development of beadwork among the Kiowa, Comanche, and Ute of the southern Plains Indians (cat. nos. 50, 70, 76–78). Ancient trade contacts between the Crow and the Nez Perce stimulated an artistic interaction between these and other tribes on the Columbia River (cat. nos. 47, 53, 60). Similar art contacts are noticeable between the Blackfeet and Plateau Indians (cat. no. 22).

In the 1830s the ethnic cleansing of the southeastern and midwestern states by the American government created a melting pot of diverse Native American art traditions along the Lower Missouri and in present-day Oklahoma. Unrelenting government efforts to destroy the Native cultures met with stubborn resistance. Resulting from intensified intertribal contacts, a new style of beadwork emerged on ceremonial costumes. Shared by local and immigrant tribes alike, this "Prairie style," which is characterized by stylized floral and abstract forms (cat. nos. 39–41), reflected the Native willingness to sacrifice tribal distinctions in order to maintain an "Indian" identity. It was a creative and significant gesture that presaged the modern renaissance in Indian culture.

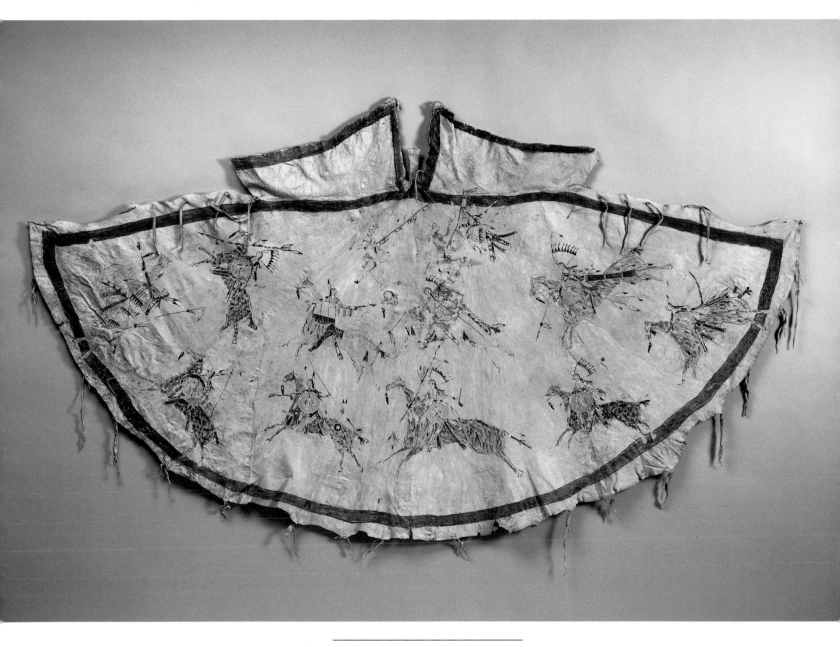

13. Tipi model, 1880s

Central Plains, Teton Sioux
Native-tanned skin, pigment;
38 × 66 in. (96.5 × 167.6 cm)
Published: Feder 1971, pl. 17
Ex coll.: Said to have been collected
by Major L. F. Spencer on the
Rosebud Reservation, Dakota
Territory, 1888

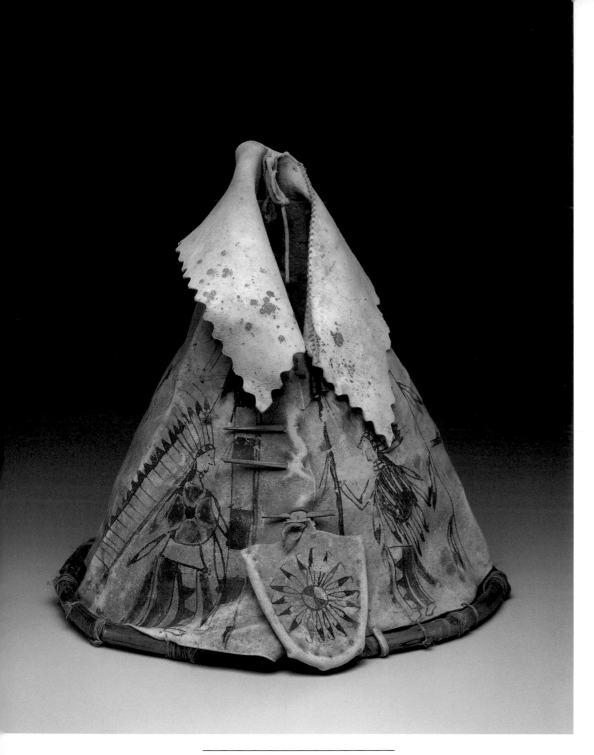

14. Toy tipi, 1880s

Central Plains, Teton Sioux
Native-tanned skin, pigment, glass
beads, wood; 10¾ × 10¾ in. (27.3 ×
27.3 cm)
Published: Phelps 1976, no. 1587
Ex coll.: James Hooper, London,
England

15. Ceremonial robe,
ca. 1880

Southwest, Western
Apache
Native-tanned skin,
pigment; 76 × 54 in.
(193 × 137.2 cm)

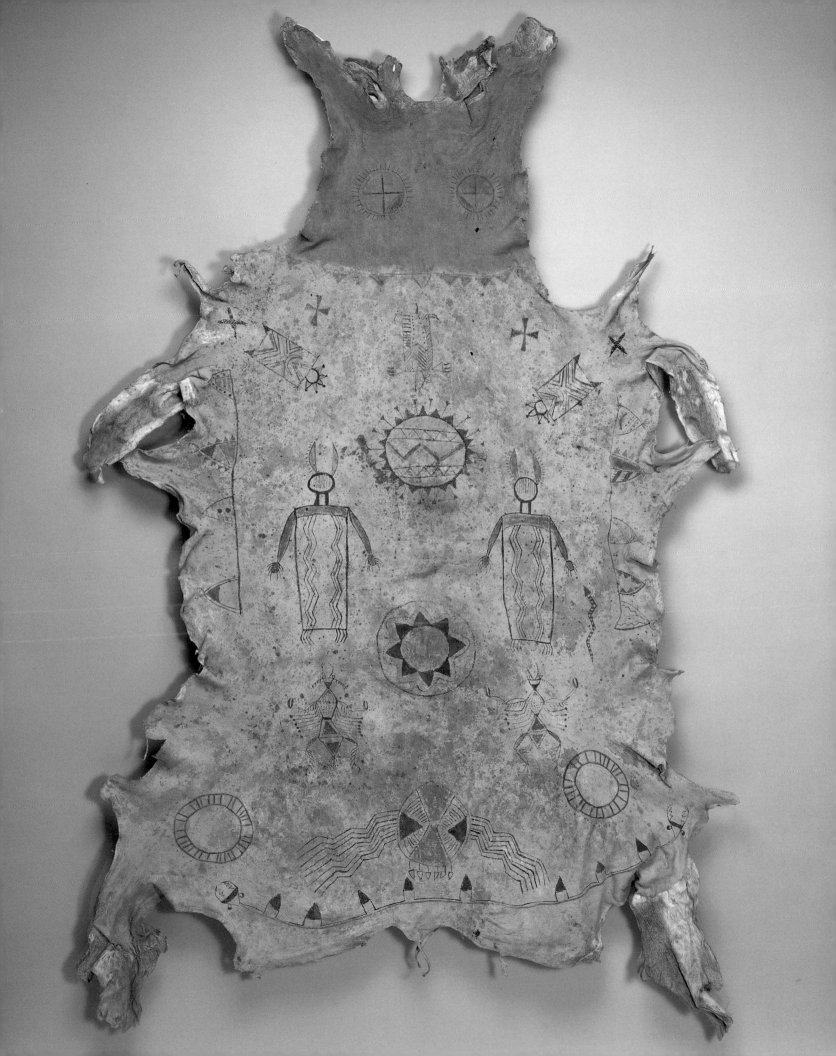

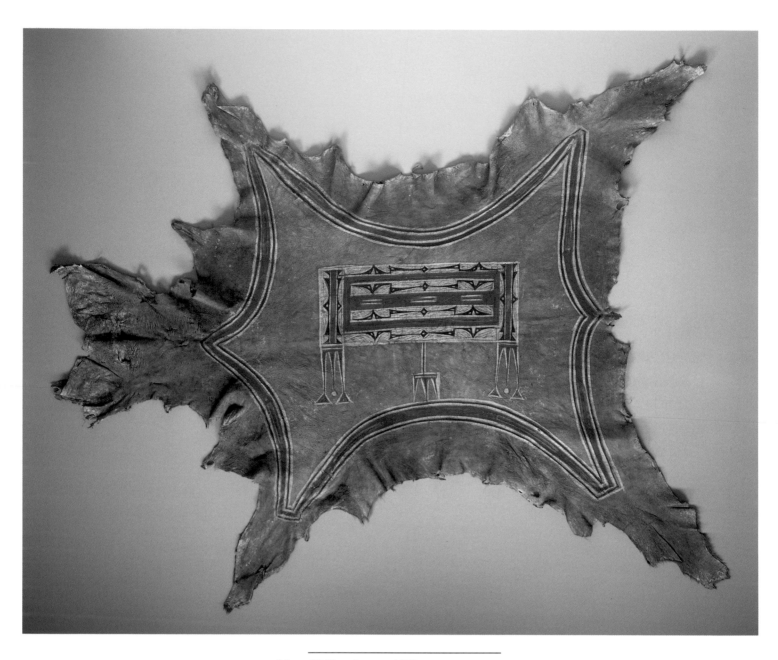

16. **Girl's robe, ca. 1870**

Central Plains, Arapaho
Native-tanned skin, pigment; 55⅛ ×
62 in. (140 × 157 cm)

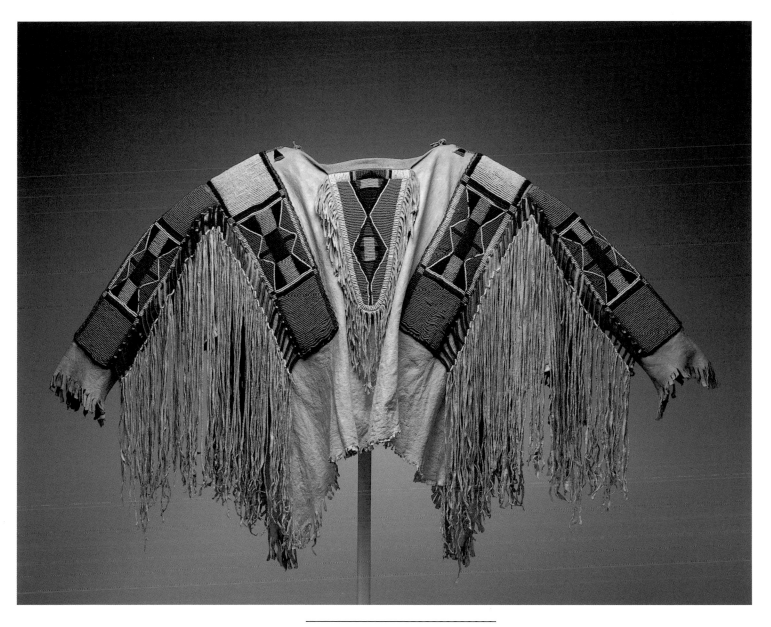

17. Boy's shirt, ca. 1900

Northern Plains, Crow
Native-tanned skin, glass beads,
wool yarn; 24 × 48½ in. across arms
(60.8 × 123 cm), excluding fringe

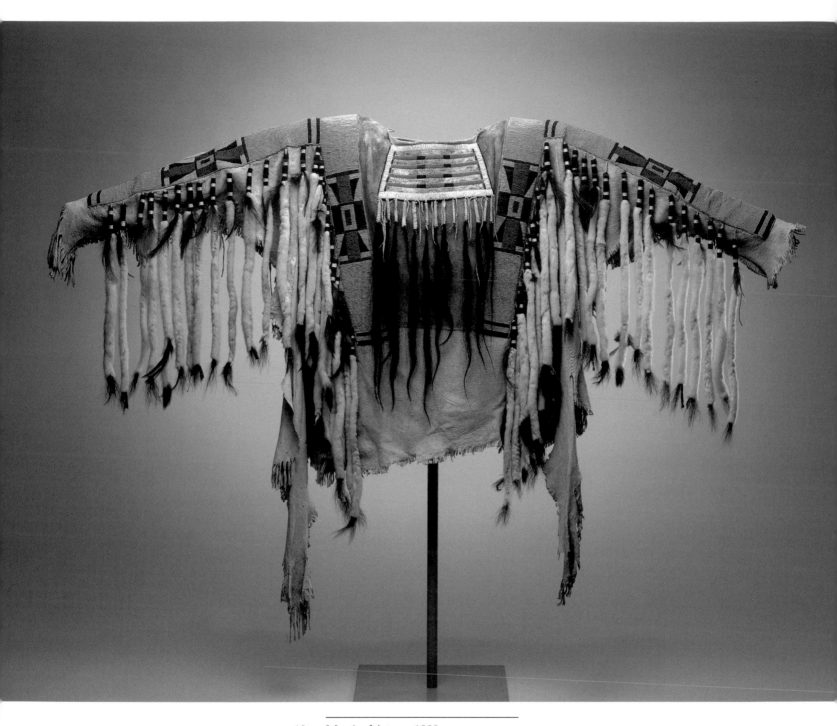

18. Man's shirt, ca. 1880

Northern Plains, Crow
Native-tanned skin, factory-woven
cloth, glass beads, pigment, ermine,
hair locks, feathers; 41 × 59⅞ in.
across arms (104.1 × 152.1 cm),
including fringe
Ex coll.: Possibly made for the Crow
chief Wolf Lies Down, 1843?–after
1908; Chandler/Pohrt Collection,
Flint, Mich.

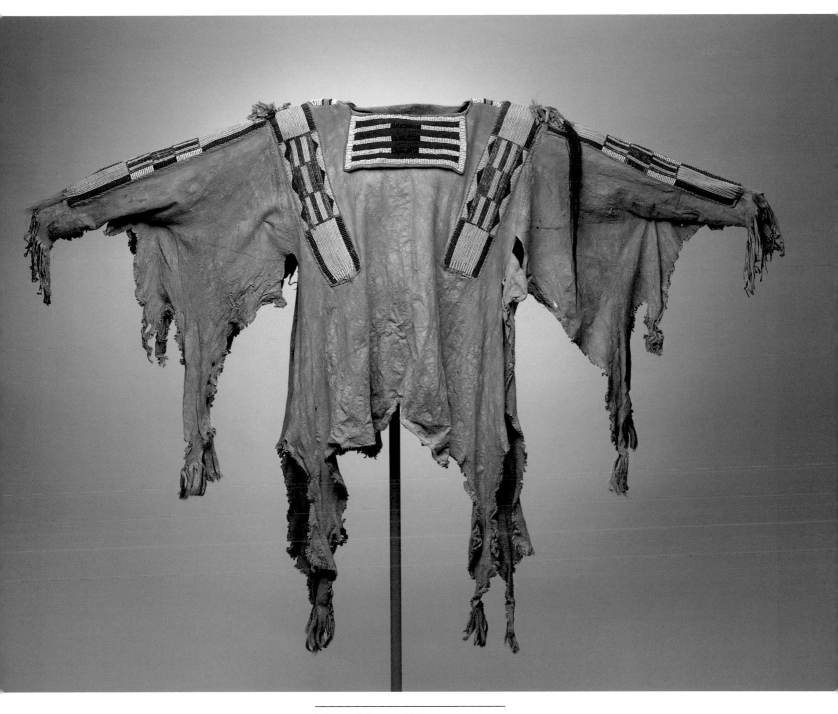

19. Man's shirt, ca. 1860

Northern Plains, Crow
Native-tanned skin, factory-woven
cloth, porcupine quill, glass beads,
horsehair, wool yarn, ermine; 41⅜ ×
63⅜ in. across arms (105.1 × 161 cm),
including fringe
Ex coll.: Collected by Charles H.
Haines of Moxee, Wash., in 1884

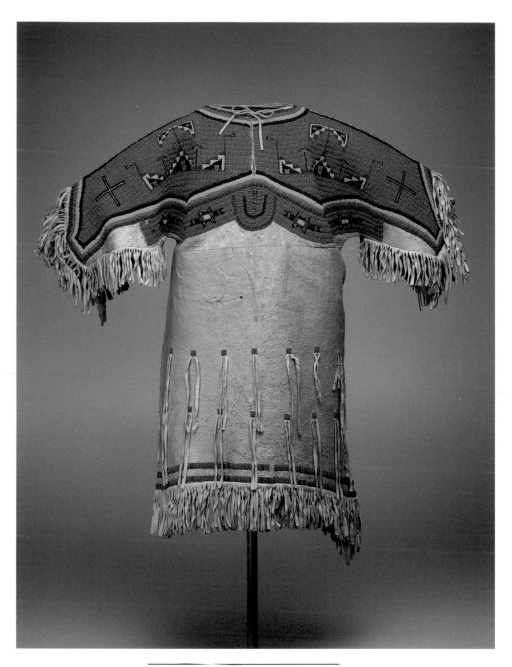

20. Girl's dress, ca. 1885

Central Plains, Teton Sioux
Native-tanned skin, glass beads; 29 ×
36 in. across arms (73.7 × 91.4 cm),
including fringe

21. Woman's dress, 1880s

Central Plains, Teton Sioux
Native-tanned skin, glass
beads; 49 × 57 in. across arms
(124.5 × 144.8 cm), excluding
fringe

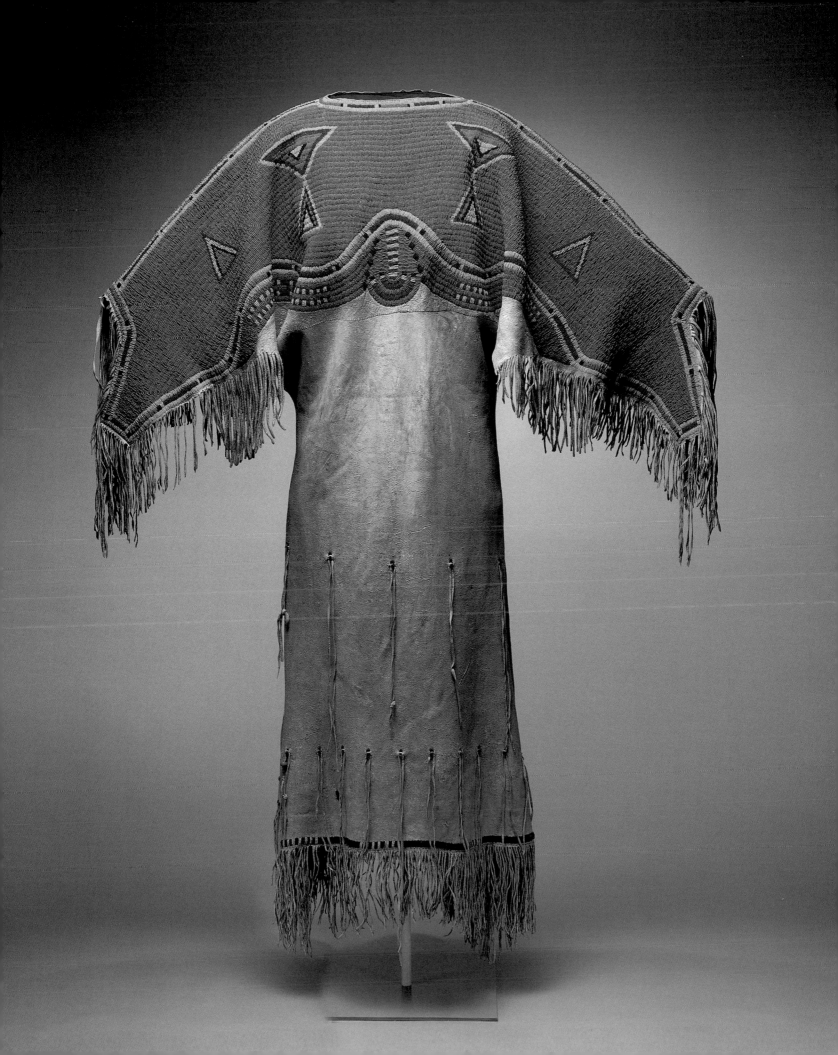

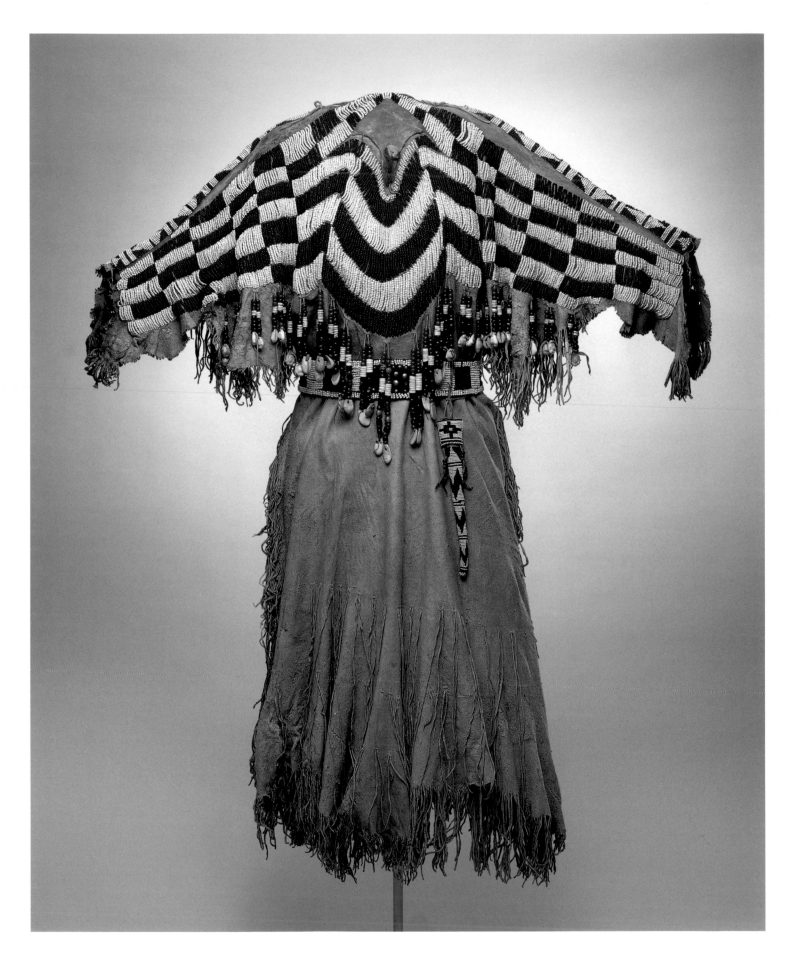

38

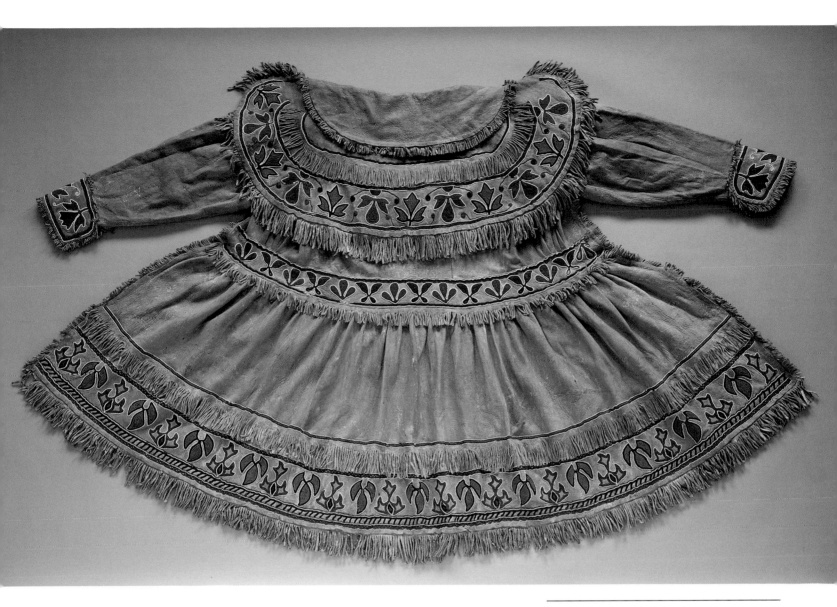

23. Man's coat, ca. 1840

Eastern Woodlands, Delaware-Shawnee (?)
Native-tanned skin, factory-woven cloth,
glass beads; 39 × 63 in. across arms (99 ×
160 cm), including fringe
Ex coll.: F. Dennis Lessard, Santa Fe, N.M.

22. Woman's dress, belt, and awl
case, ca. 1870

Plateau, Wasco
Native-tanned skin, glass beads,
shells, thimbles; belt: commercially
tanned leather, glass beads, metal
studs and cones; awl: bone; 52 ×
43½ in. across arms (132.1 × 110.5
cm), including fringe; belt: 34⅝ ×
2½ in. (87.9 × 6.4 cm); case: 10¼ ×
1⅝ in. (26 × 4.1 cm)
Ex coll.: Said to have been pur-
chased from Leona Moses, Yakima
Reservation, Wash., 1970

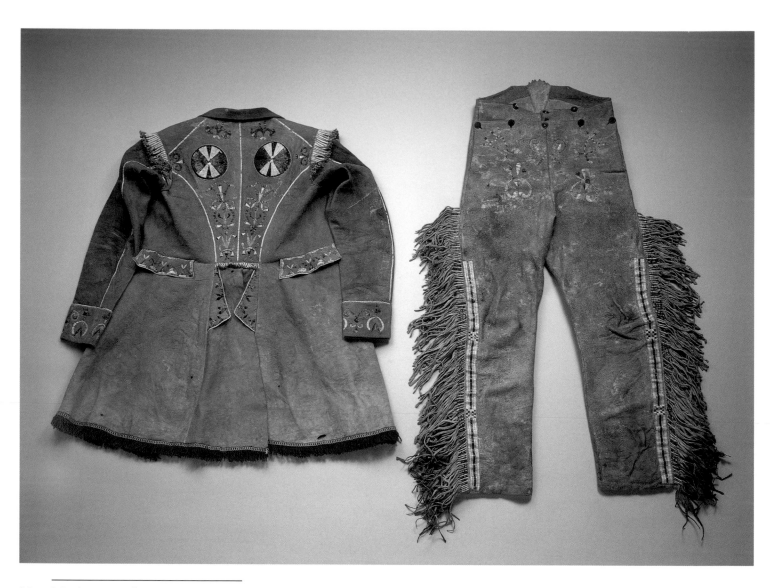

24. Man's coat and trousers, 1840s

Northern Plains, Sioux-Métis
Native-tanned skin, porcupine quill,
wool yarn; 36½ × 67½ in. across
arms (171.5 × 43.2 cm); trousers:
41½ × 31 in. waist circumference
(105.4 × 78.7 cm)

25. Man's summer coat, ca. 1840

Eastern Woodlands, Naskapi
Native-tanned skin, pigment;
41½ × 69¼ in. across arms
(105.4 × 175.9 cm)

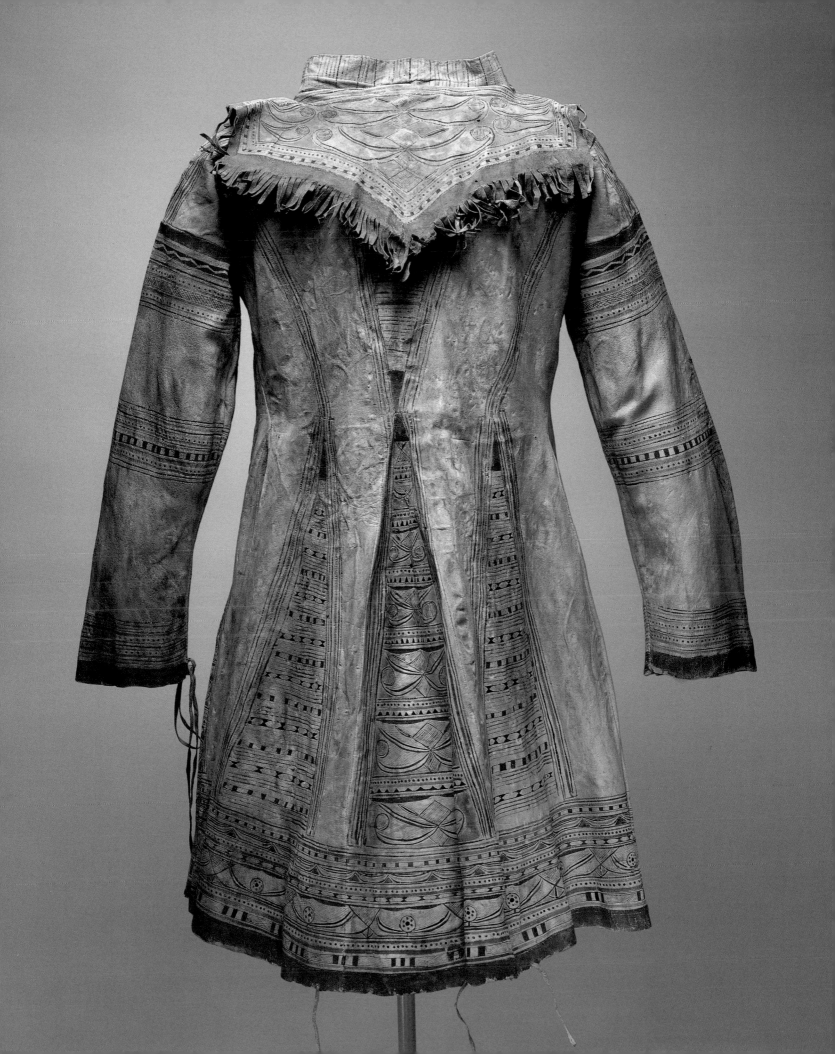

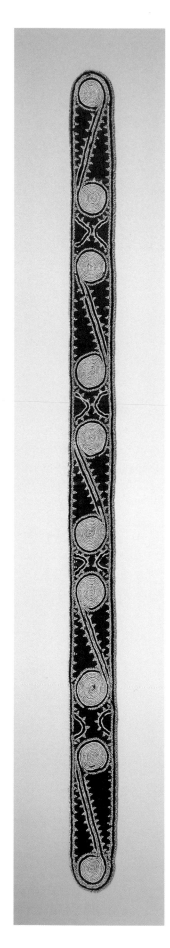

26. Bandoleer, 1780s

Eastern Woodlands,
Choctaw
Factory-woven
cloth, glass beads;
56¾ × 3¼ in.
(144.1 × 8.3 cm)
Published: Christie's
(London), June 25,
1984, lot 9
Ex coll.: Said to
have been collected
by Thomas Hurd of
the British Navy
between 1782 and
1795

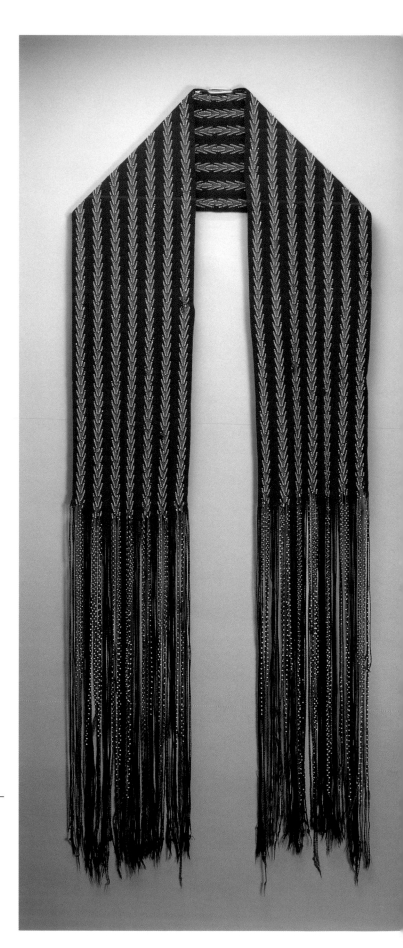

**27. Fingerwoven sash,
ca. 1830**

Eastern Woodlands,
Huron
Wool yarn, glass
beads; 74½ × 10⅜ in.
(189.2 × 26.4 cm),
excluding fringe

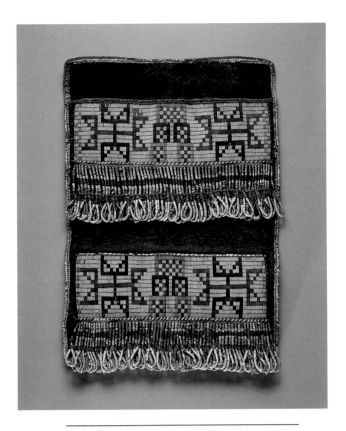

28. Shot pouch, ca. 1820

Eastern Woodlands, Saulteaux-Métis (?)
Native-tanned and -dyed skin,
porcupine quill; 10 × 6½ in. (25.4 × 16.5 cm)

29. Shot pouch, 1780s

Eastern Woodlands, Minnesota
Ojibwa (?)
Native-tanned and -dyed skin, por-
cupine quill, metal cones, deer-hair
tassels; 7½ × 7¼ in. (19 × 18.5 cm);
strap: L. 24 in. (61 cm), excluding
tassels
Ex coll.: Warwick Castle Collection,
Warwickshire, England

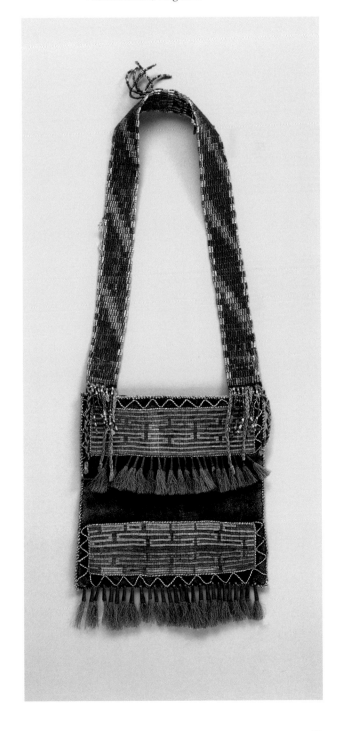

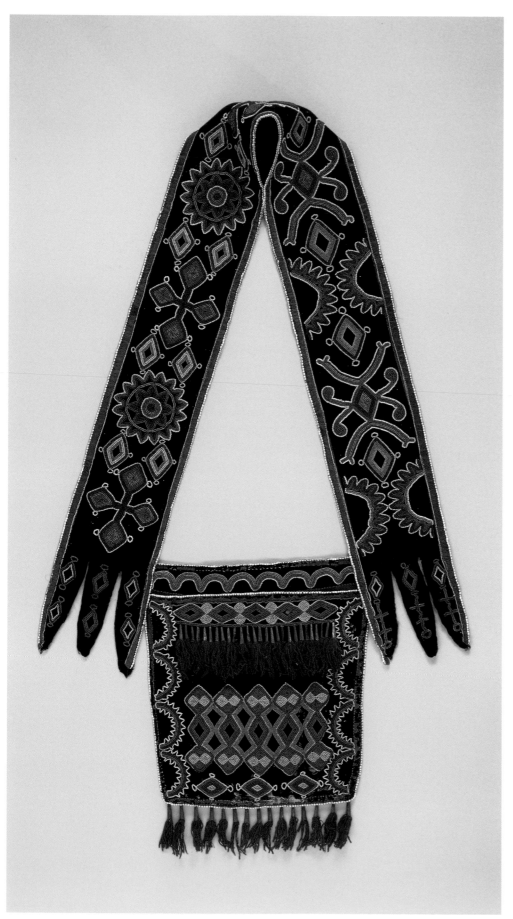

30. Bandoleer bag, ca. 1870

Eastern Woodlands, Delaware
Factory-woven cloth, glass beads,
ribbon, metal cones, wool tassels;
9⅝ × 8⅞ in. (24.5 × 22.5 cm), exclud-
ing tassels; strap,
L. 47⅝ in. (121 cm)

31. Bandoleer bag, ca. 1830

Eastern Woodlands,
Seminole
Factory-woven cloth, glass
beads, ribbon, silk tassels;
7¾ × 6⅞ in. (18.4 × 17.5 cm);
strap, L. 50¾ in. (129 cm),
excluding tassels
Ex coll.: Bud Wellman,
Boston, Mass.

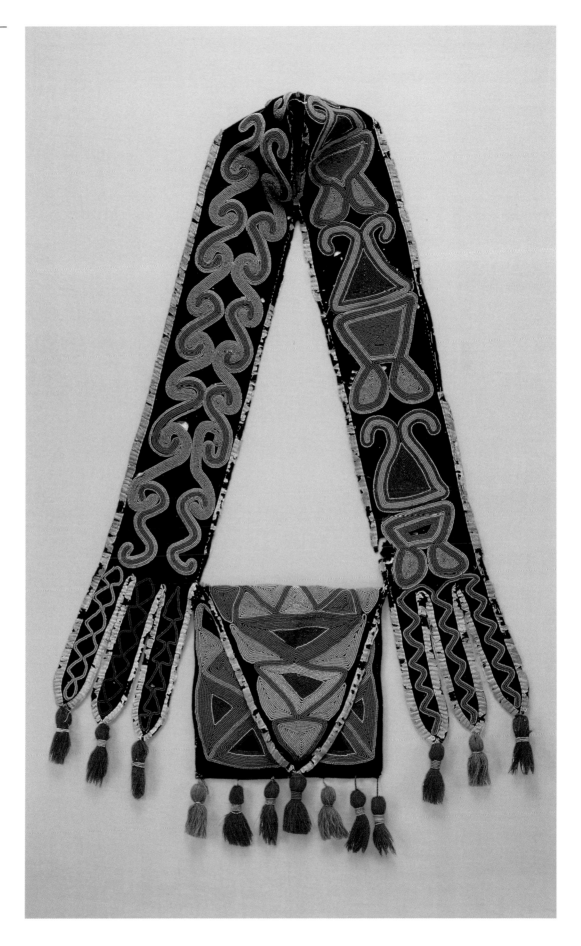

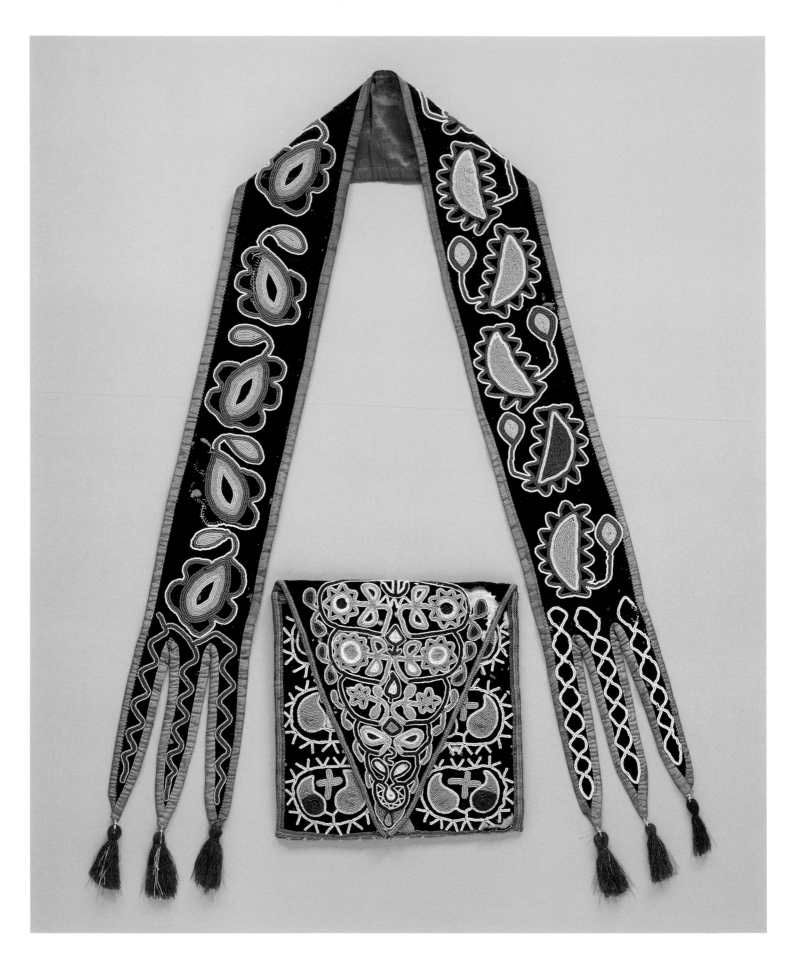

46

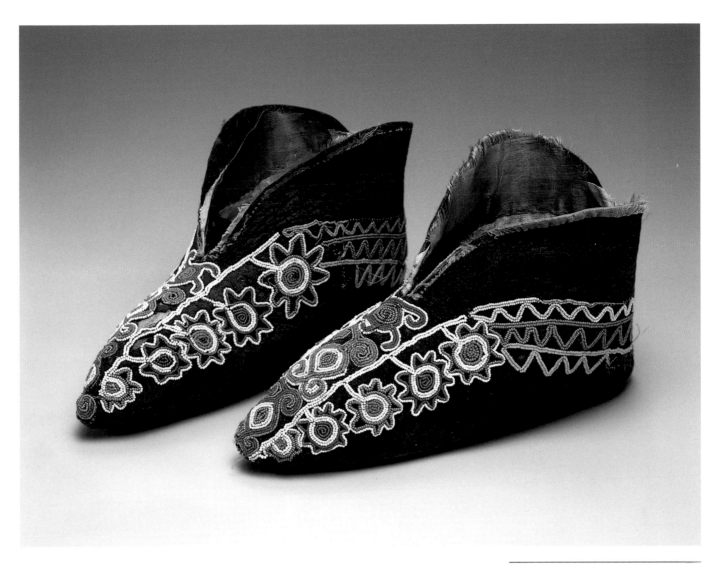

33. **Pair of moccasins, ca. 1830**

Eastern Woodlands, Cherokee or
Seminole (?)
Native-tanned skin, factory-woven
cloth, glass beads, ribbon; 3⅞ × 9 in.
(10 × 23 cm)
Published: Christie's (London),
June 23, 1992, lot 133

32. **Bandoleer bag, ca. 1830**

Eastern Woodlands, Cherokee or
Seminole (?)
Factory-woven cloth, glass beads,
ribbon, silk tassels; 9⅛ × 8⅞ in. (23 ×
22.5 cm); strap, L. 55⅜ in. (140.5 cm),
excluding tassels
Published: Christie's (London),
June 23, 1992, lots 133, 134

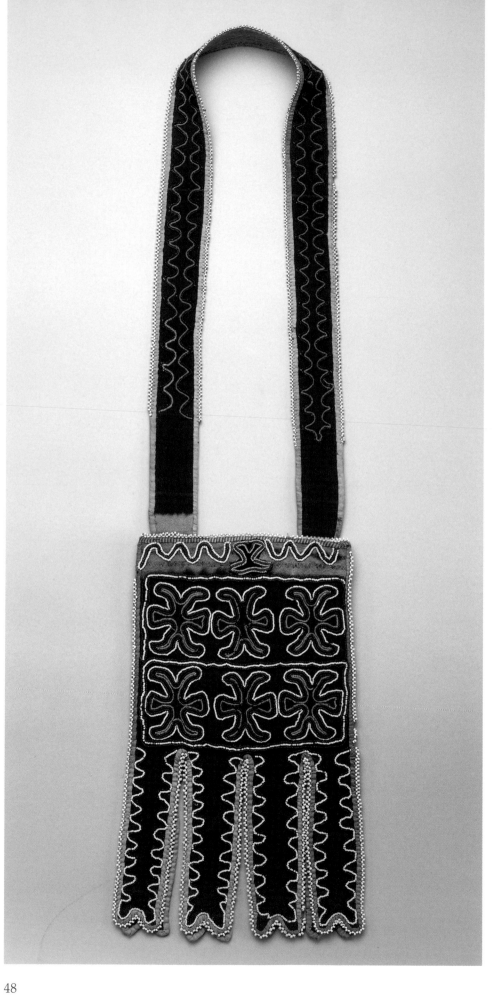

34. Shoulder bag, ca. 1870

Northern Athapascan, Tahltan
Factory-woven cloth, glass beads;
13⅝ × 7⅞ in. (34.5 × 20 cm); strap,
L. 38½ in. (97.7 cm)

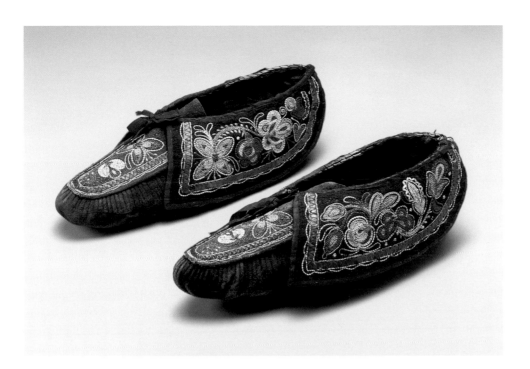

35. **Pair of moccasins, ca. 1830**

Eastern Woodlands, Huron
Native-tanned and -dyed skin,
moose hair, porcupine quill, ribbon;
2½ × 8⅞ in. (6.5 × 22.5 cm)
Published: Christie's (London),
June 26, 1995, lot 199

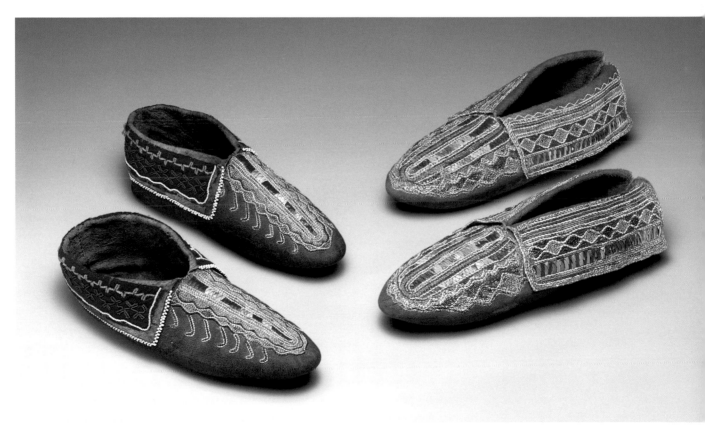

36. **Pair of moccasins, ca. 1820**

Eastern Woodlands, Iroquois
Native-tanned skin, porcupine quill,
glass beads, ribbon; 2½ × 9 in. (6.4 ×
22.9 cm)
Ex coll.: Chandler/Pohrt Collection,
no. 1287, Flint, Mich.

37. **Pair of moccasins, ca. 1830**

Eastern Woodlands, Iroquois
Native-tanned skin, porcupine quill;
3½ × 9¾ in. (9 × 25 cm)
Ex coll.: Allan Silverberg, Littleton,
Mass.

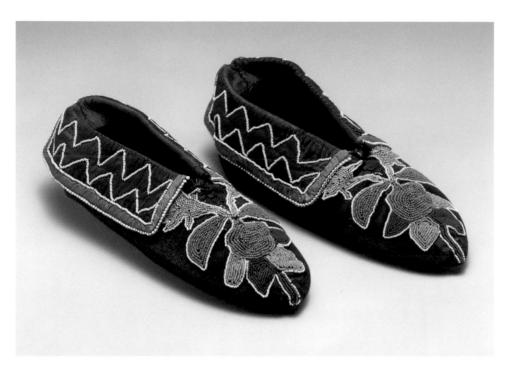

38. **Pair of moccasins, ca. 1830**

Eastern Woodlands, Muskogee (?)
Native-tanned and dyed skin, glass
beads, ribbon; 2½ × 7⅝ in. (6.5 ×
19.5 cm)

39. **Pair of moccasins, ca. 1880**

Prairie, Iowa or Oto-Missouri
Native-tanned skin, factory-woven
cloth, glass beads; 3¼ × 10⅝ in.
(8 × 27 cm)

40. **Pair of moccasins, 1880s**

Prairie, Potawatomi-Prairie
Native-tanned skin, factory-woven
cloth, glass beads; 2⅜ × 9⅛ in.
(6 × 23.2 cm)

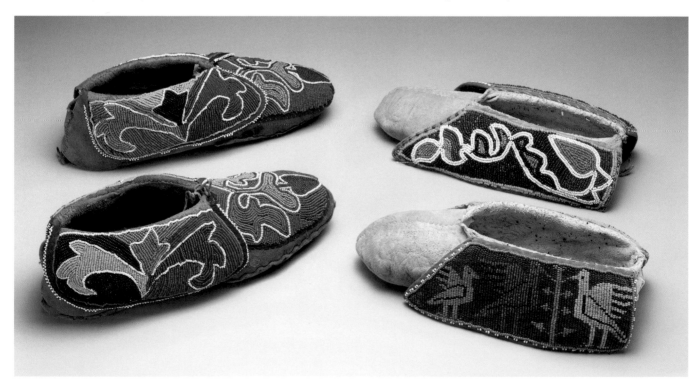

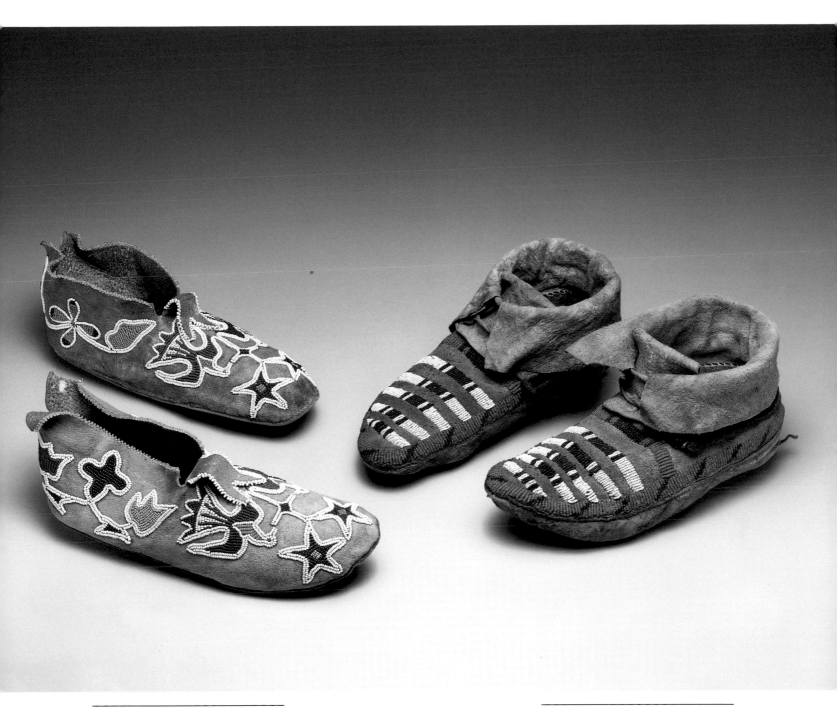

41. **Pair of moccasins, ca. 1890**

Prairie, Oto-Missouri
Native-tanned skin, glass beads; 3½ ×
10 in. (8.9 × 25.4 cm)
Ex coll.: David Wooley, Moorhead,
Minn.

42. **Pair of moccasins, ca. 1900**

Northern Plains, Crow
Native-tanned skin, factory-woven
cloth, glass beads, pigment; 4½ ×
10¼ in. (11.4 × 26 cm)

43. Pair of moccasins, ca. 1910

Eastern Woodlands, Naskapi-
Montagnais
Native-tanned skin, factory-
woven cloth, silk thread; 6¾ ×
10⅝ in. (17 × 27 cm)
Ex coll.: F. Dennis Lessard,
Santa Fe, N.M.

44. Pair of moccasins, ca. 1880

Southern Plains, Mescalero Apache
Native-tanned skin, factory-woven
cloth, glass beads, metal studs; 3½ ×
10⅝ in. (9 × 27 cm)

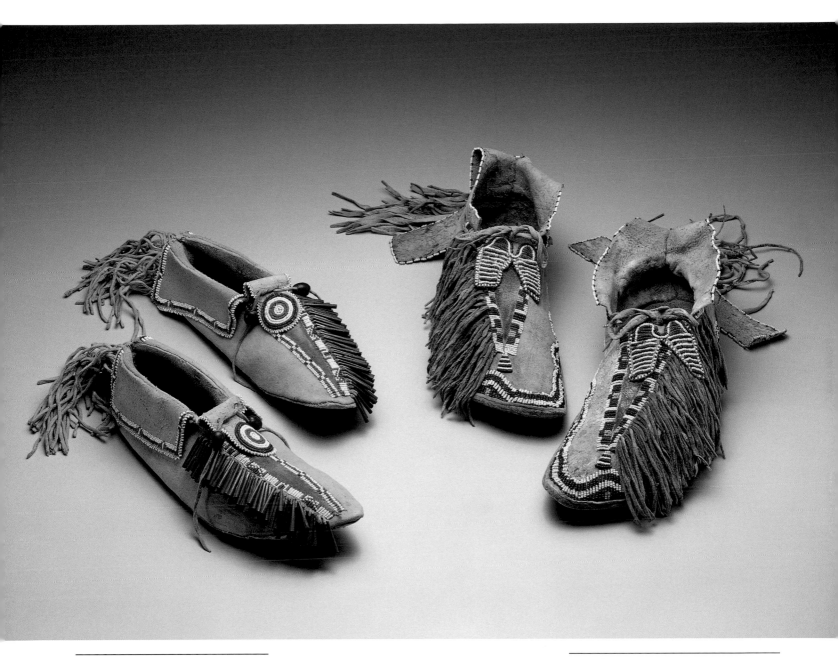

45. Pair of moccasins, ca. 1870

Southern Plains, Kiowa
Native-tanned skin, glass beads,
metal cones, pigment, seeds; 2⅛ ×
10 in. (5.5 × 25.5 cm)

46. Pair of moccasins, ca. 1870

Southern Plains, Comanche
Native-tanned skin, glass beads, pig-
ment; 2¾ × 11 in. (7 × 28 cm)
Published: Sotheby's (New York),
October 23, 1981, lot 40
Ex coll.: Sally Biddle, Washington, D.C.

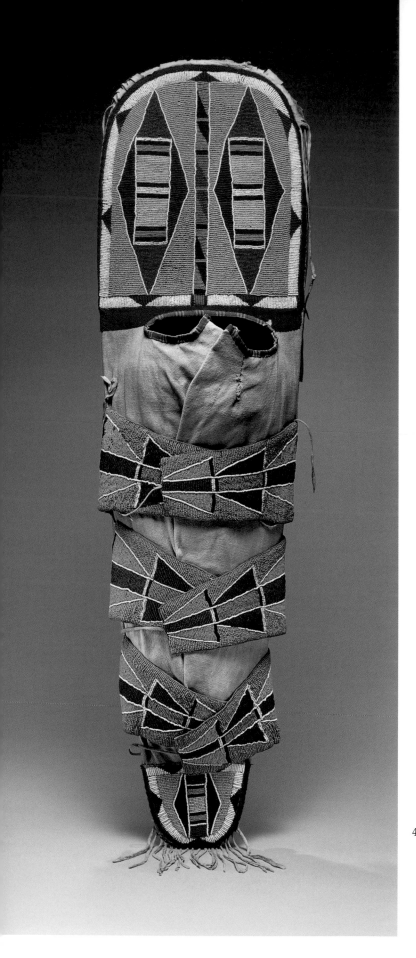

48. **Baby carrier, ca. 1900** (left)

Southern Plains, Kiowa
Native-tanned skin, factory-woven cloth, wood, glass beads, metal studs; 42½ × 11⅞ in. (108 × 30 cm)

49. **Baby carrier, ca. 1900** (right)

Southern Plains, Comanche
Native-tanned skin, factory-woven cloth, wood, glass beads, metal studs; 40¾ × 10⅞ in. (103.5 × 27.6 cm)

47. **Baby carrier, ca. 1880**

Northern Plains, Crow
Native-tanned skin, factory-woven cloth, wood, glass beads; 38½ × 10¼ in. (97.8 × 26 cm)
Ex coll.: Chandler/Pohrt Collection, no. 2554, Flint, Mich.

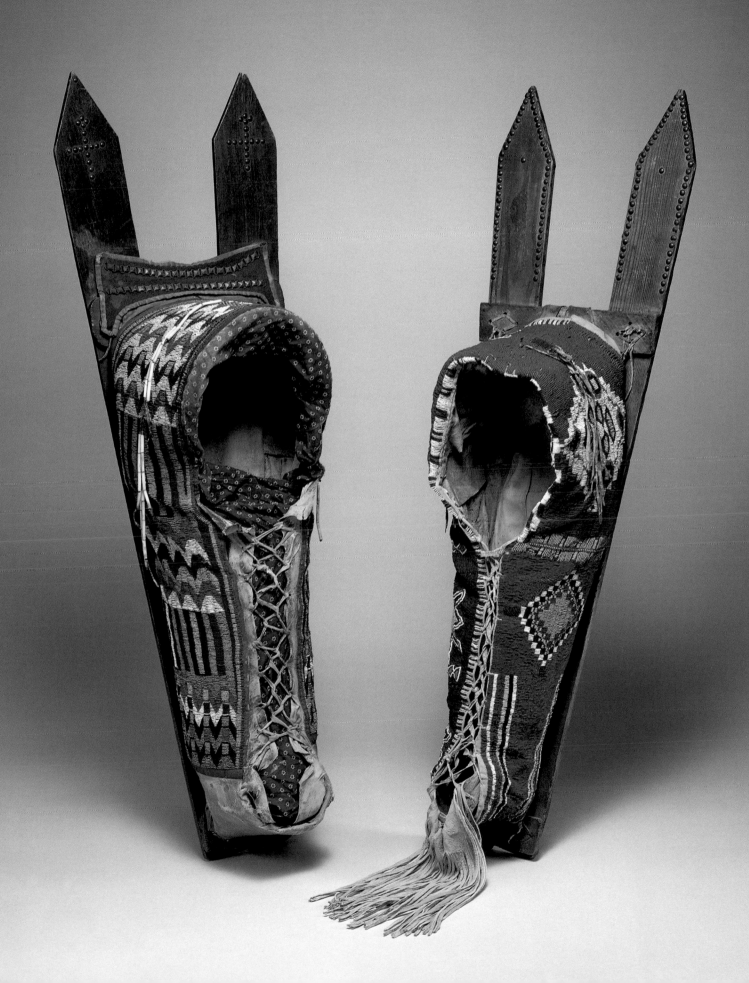

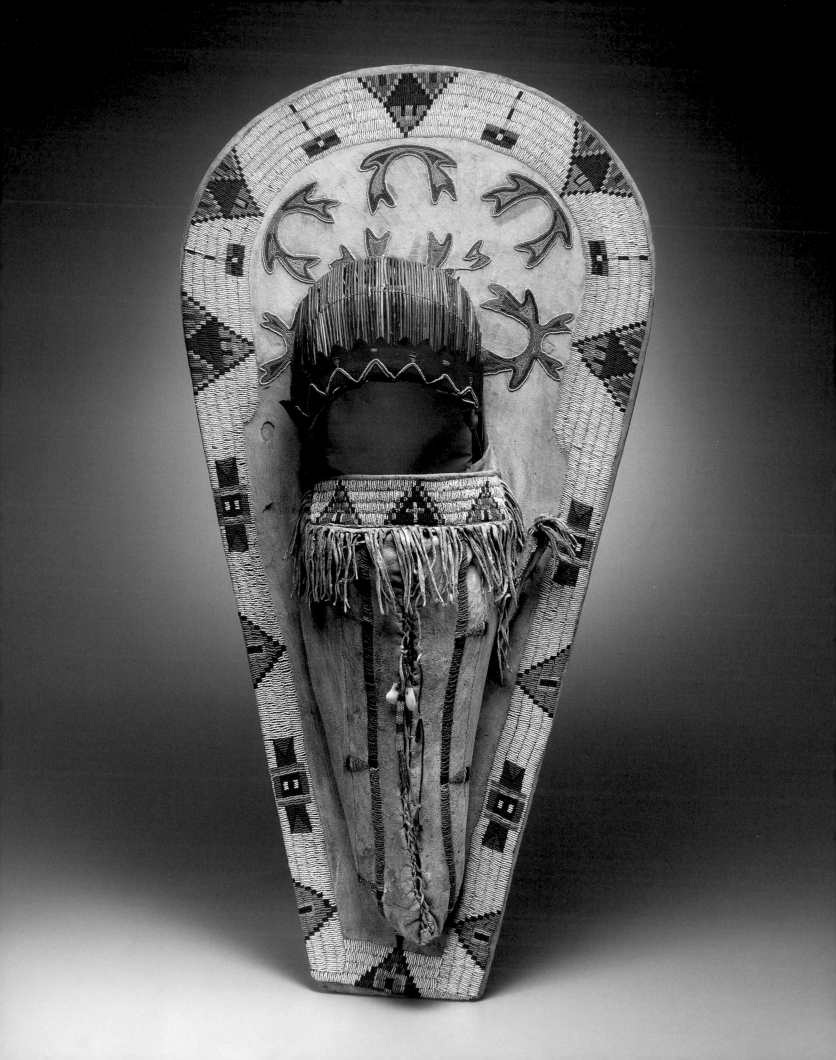

51. Tea cozy, ca. 1900

Eastern Woodlands, Micmac
Factory-woven cloth, glass beads,
ribbon; 13¼ × 18¾ in. (33.7 ×
47.6 cm)

52. Woman's hood, 1880s

Eastern Woodlands,
Micmac
Factory-woven cloth, glass
beads, ribbon; 14⅜ × 8⅛ in.
(36.5 × 20.5 cm)
Published: Christie's
(London), December 3,
1991, lot 20

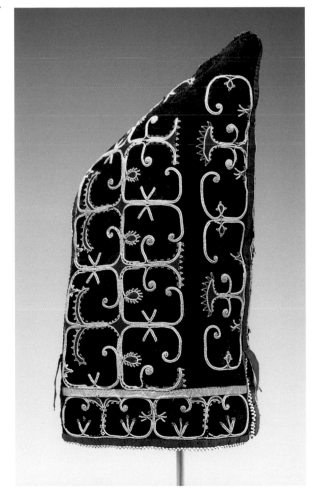

50. Baby carrier, ca. 1890

Southern Plains, Ute
Native-tanned skin,
wood, glass beads, bone;
40½ × 20¾ in. (102.9 ×
52.7 cm)

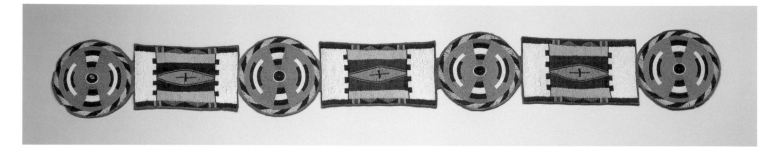

53. Blanket strip, ca. 1875

Northern Plains, Crow
Native-tanned skin, glass beads; 7¼ ×
58½ in. (18.4 × 148.6 cm)
Ex coll.: L. Drew Bax, Denver, Colo.

54. Lance case, ca. 1870

Northern Plains, Crow
Native-tanned skin, rawhide, factory-woven cloth, glass beads, metal bells; 42 × 6⅞ in. (106.7 × 17.5 cm), excluding fringe

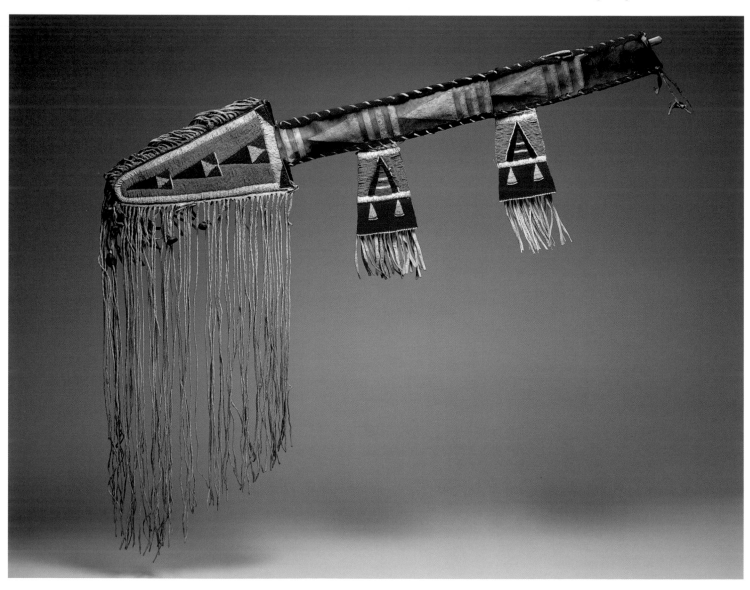

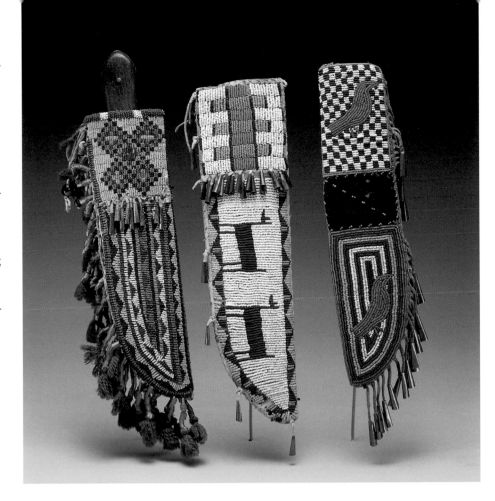

55. Knife sheath, ca. 1890 (left)

Central Plains, Sioux
Native-tanned skin, glass beads,
wool tassels; knife: metal, wood; 9¼ ×
2¾ in. (23.5 × 7 cm); with knife:
L. 11 in. (28 cm), excluding tassels

56. Knife sheath, ca. 1890 (center)

Central Plains, Cheyenne
Rawhide, glass beads, metal cones;
11⅛ × 3 in. (28.3 × 7.5 cm), excluding
tassels

57. Knife sheath, ca. 1870 (right)

Northern Plains, Plains Ojibwa
Native-tanned skin, glass beads,
factory-woven cloth, metal cones;
10¼ × 2⅜ in. (26 × 6 cm), excluding
tassels

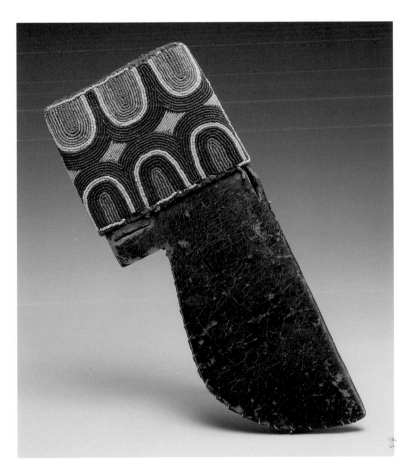

58. Knife sheath, 1870s

Central Plains, Teton Sioux
Commercially tanned leather,
glass beads, metal; 10⅜ × 4⅛ in.
(26.4 × 10.5 cm)
Ex coll.: Chandler/Pohrt
Collection, no. 3238, Flint, Mich.

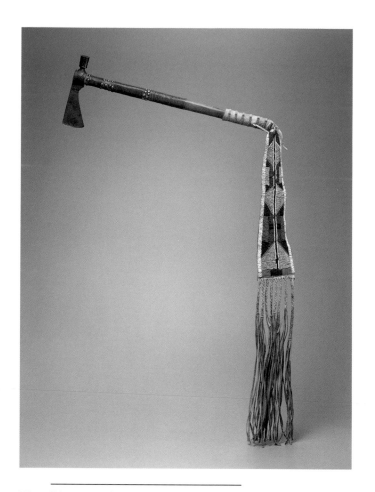

59. Pipe-tomahawk, ca. 1880

Northern Plains, Crow
Metal, wood, native-tanned skin,
glass beads; 8 × 37⅞ in. (20.3 × 96
cm), excluding fringe

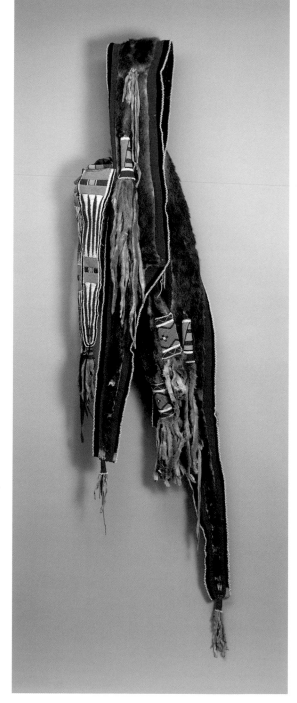

60. Bowcase-quiver, ca. 1870

Northern Plains, Nez Perce
Otter skin, native-tanned skin,
factory-woven cloth, glass beads,
ermine, ribbon;
L. 45 in. overall (115 cm), exclud-
ing fringe; quiver: 32¼ × 6¼ in.
(81.9 × 15.9 cm); bowcase: 38½ ×
3⅝ in. (97.8 × 9.2 cm)
Published: Holm 1981, p. 63, fig. 4
Ex coll.: L. Drew Bax, Denver,
Colo.; Bud Wellman, Boston,
Mass.

61. Revolver holster, 1870s (2 views)

Prairie, Eastern Sioux (?)
Native-tanned skin, porcupine quill,
glass beads, metal cones, horsehair
tassels; 11¾ × 5½ in. (30 × 14 cm),
excluding fringe
Published: Miles 1963, no. 4.84 and
no. 7.169
Ex coll.: Charles Miles, Oakland, Calif.

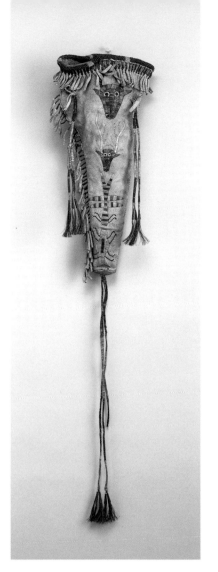 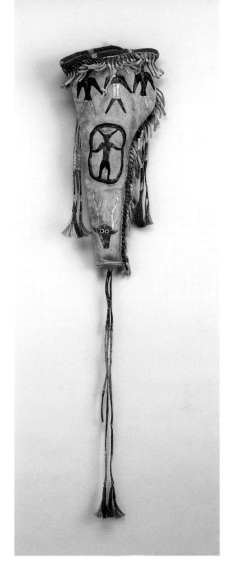

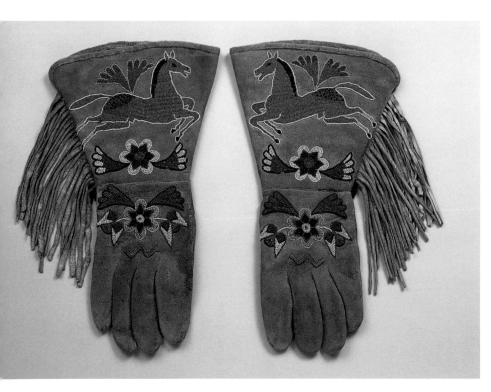

62. Gauntlets, ca. 1900

Plateau, Nez Perce (?)
Native-tanned skin, factory-woven
cloth, glass beads; 14 × 7⅞ in. (35.5 ×
19.5 cm)

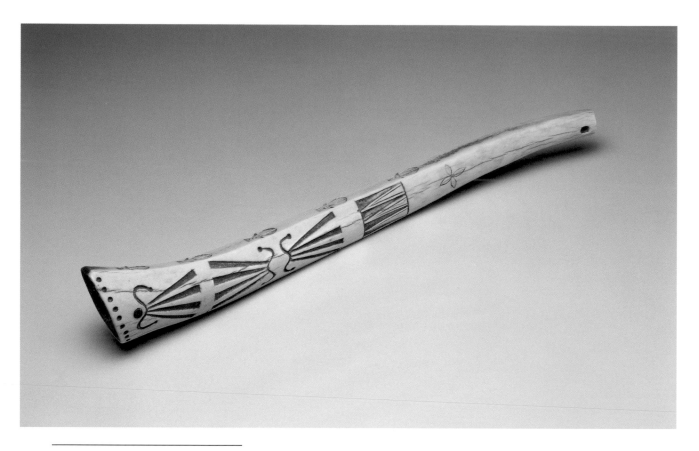

63. **Horsewhip (quirt) handle, ca. 1860**

Prairie, Mesquakie (?)
Antler, pigment; 14⅝ × 2 in. (37.2 × 5 cm)

64. **Grassdance flute, 1870s**

Northern Plains, Sioux
Wood, fur, pigment, glass beads, metal; 29⅝ × 1⅜ in. (75.2 × 3.5 cm)
Ex coll.: Chandler/Pohrt Collection, Flint, Mich.

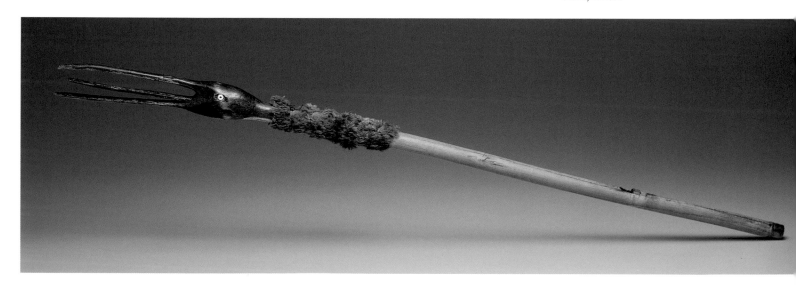

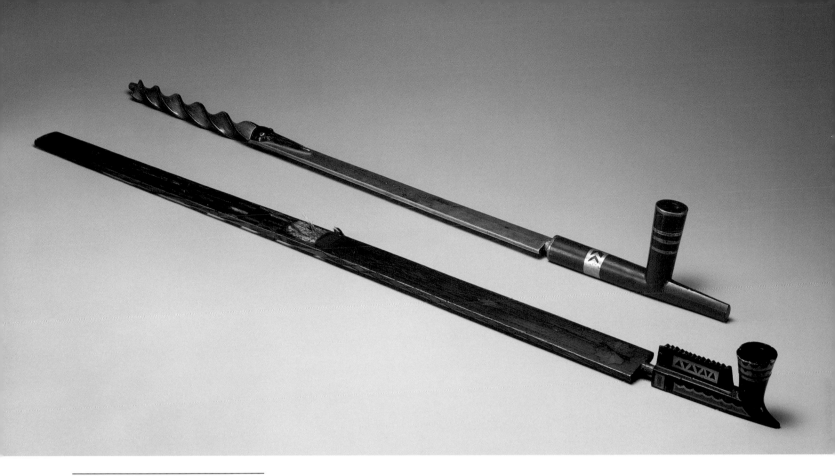

65. Ceremonial pipe, 1860s (top)

Prairie, Eastern Sioux (?)
Stone, metal inlay; stem: wood, pigment; 4½ × 35 in. (11.4 × 88.9 cm)

66. Ceremonial pipe with puzzle stem, ca. 1850 (bottom)

Eastern Woodlands, Minnesota
Ojibwa (?)
Stone, metal inlay; stem: wood, pigment, bird scalp, ribbon; 3 × 39¼ in. (7.6 × 99.7 cm)

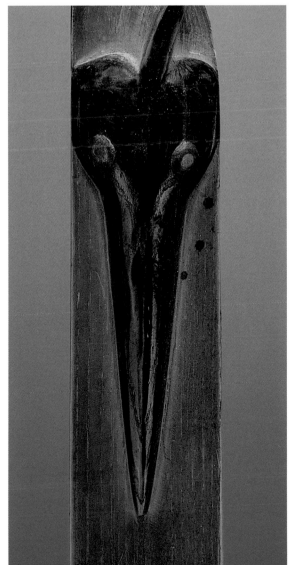

Detail of cat. no. 65

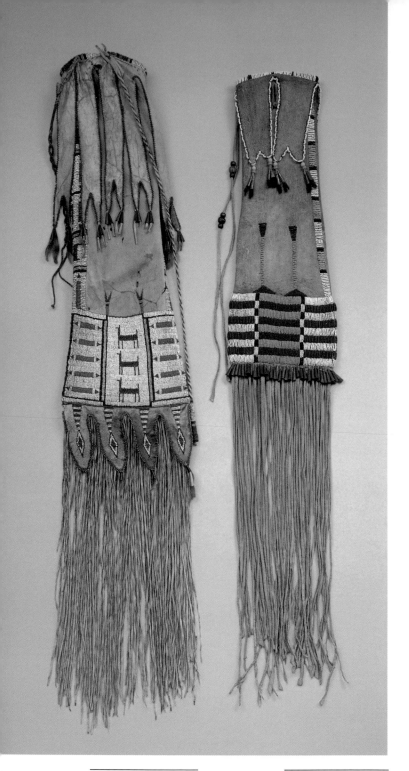

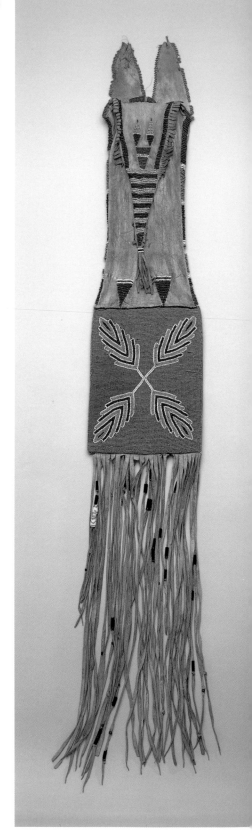

67. **Tobacco bag, ca. 1890**

Central Plains, Cheyenne
Native-tanned skin, factory-woven cloth, glass beads, metal cones; 16⅞ × 6¼ in. (43 × 16 cm), excluding fringe

68. **Tobacco bag, 1870s**

Central Plains, Cheyenne
Native-tanned skin, pigment, glass beads, metal cones; 14¼ × 5½ in. (36.2 × 14 cm), excluding fringe

69. **Tobacco bag, ca. 1900**

Northern Plains, Blackfeet
Native-tanned skin, glass beads; 21⅜ × 6¾ in. (54.3 × 17 cm), excluding fringe

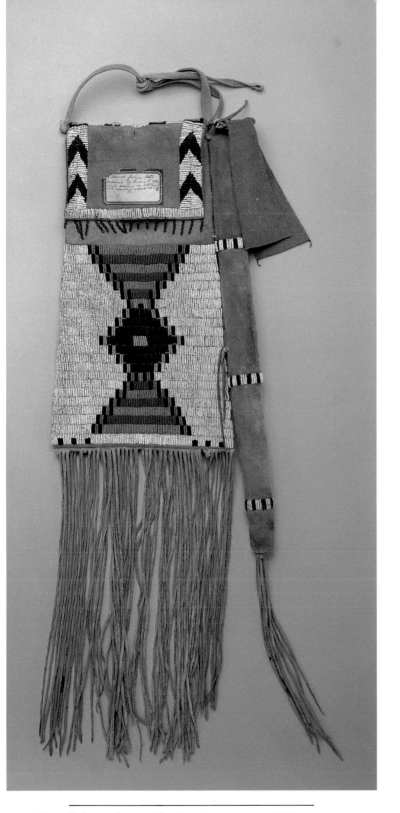

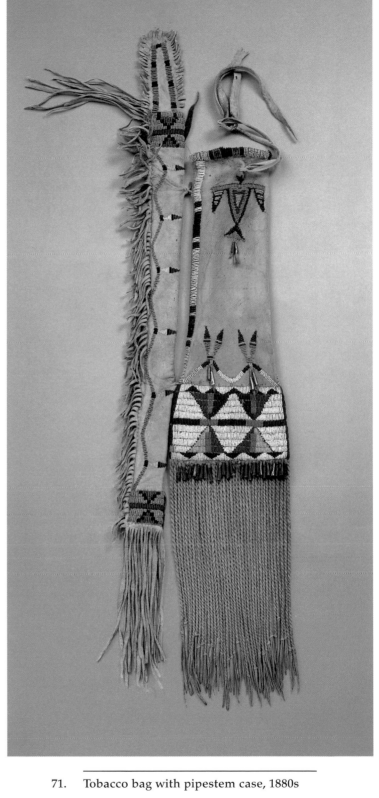

70. Tobacco bag with pipestem case, ca. 1878

Southern Plains, Ute
Native-tanned skin, glass beads, pigment, metal; 14⅜ × 7⅞ in. (36.5 × 20 cm); pipe case: 19¾ × 1¾ in. (50 × 4.5 cm), excluding fringe
Ex coll.: Label attached to bag states, "Obtained from Ute Indians by Levar [?] C. Allen while serving as 2nd Lieut. 16th Infantry about 1878"

71. Tobacco bag with pipestem case, 1880s

Central Plains, Cheyenne
Native-tanned skin, glass beads, metal cones; 14⅜ × 5¼ in. (36.5 × 13.5 cm); pipe case: 18⅞ × 1⅜ in. (48 × 3.5 cm), excluding fringe
Published: Penney 1983, fig. 9, no. 51
Ex coll.: Chandler/Pohrt Collection, no. 1163, Flint, Mich.

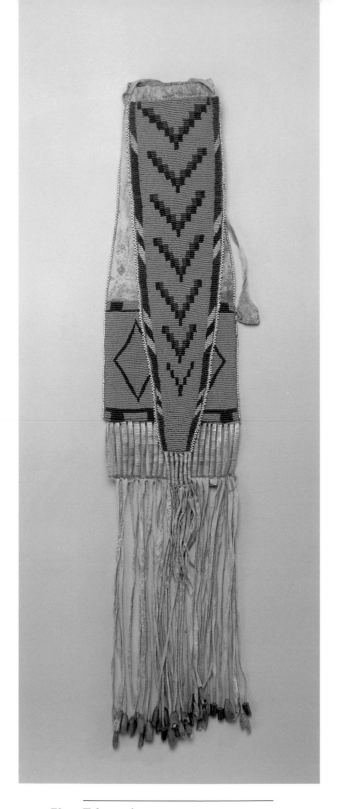

72. Tobacco bag, ca. 1880

Northern Plains, Blackfeet
Native-tanned skin, glass beads,
porcupine quill, animal claws; 13¼ ×
5½ in. (33.7 × 14 cm), excluding
fringe

73. Tobacco bag, ca. 1890

Central Plains, Teton Sioux
Native-tanned skin, glass beads,
porcupine quill; 21½ × 6¾ in. (54.6 ×
17.2 cm), excluding fringe

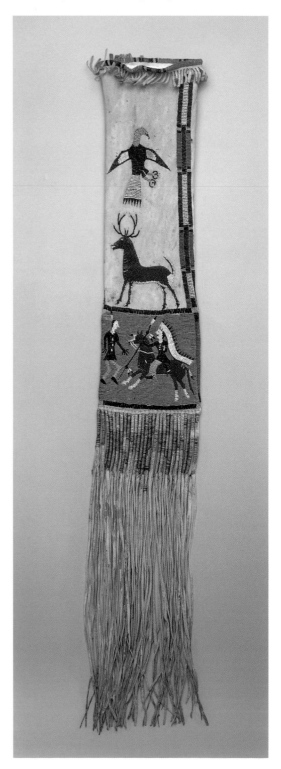

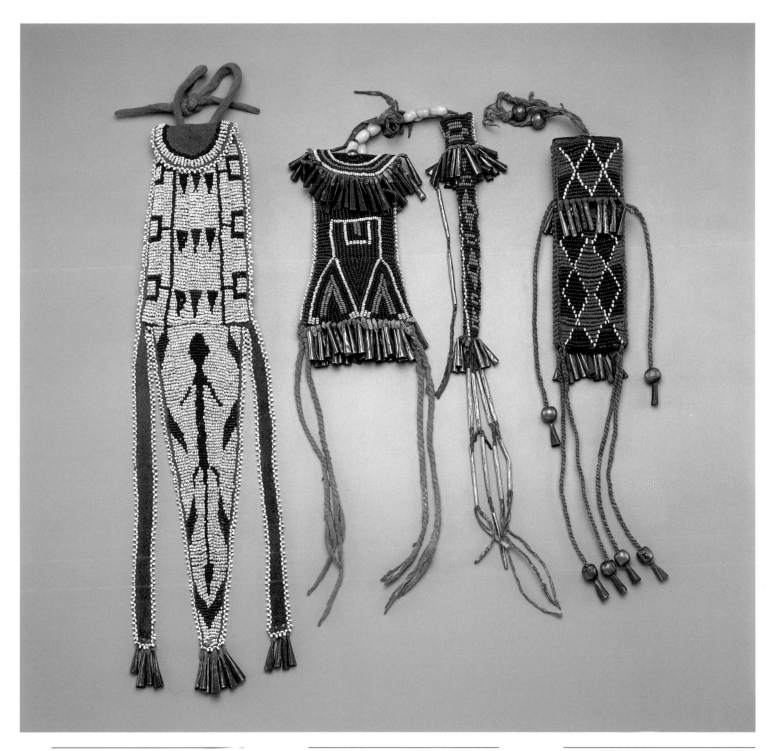

74. **Belt pouch, ca. 1880**

Southern Plains, Ute (?)
Native-tanned skin, glass beads,
metal cones; 11½ × 2½ in. (29.2 ×
6.4 cm), excluding fringe

75. **Belt pouch and awl case, ca. 1870**

Southern Plains, Kiowa
Native-tanned skin, glass beads,
metal sheaths and cones; 3¾ × 2½
in. (9.5 × 6.4 cm); case: 5 × ¾ in.
(12.7 × 1.9 cm), excluding fringe

76. **Whetstone case, ca. 1880**

Southern Plains, Kiowa (?)
Commercially tanned leather, native-
tanned skin, glass and metal beads,
metal cones; 4½ × 1⅝ in. (11.4 ×
4 cm), excluding fringe
Published: Wooley 1990, p. 101, cat.
no. 45
Ex coll.: Charles Derby, Northampton,
Mass.

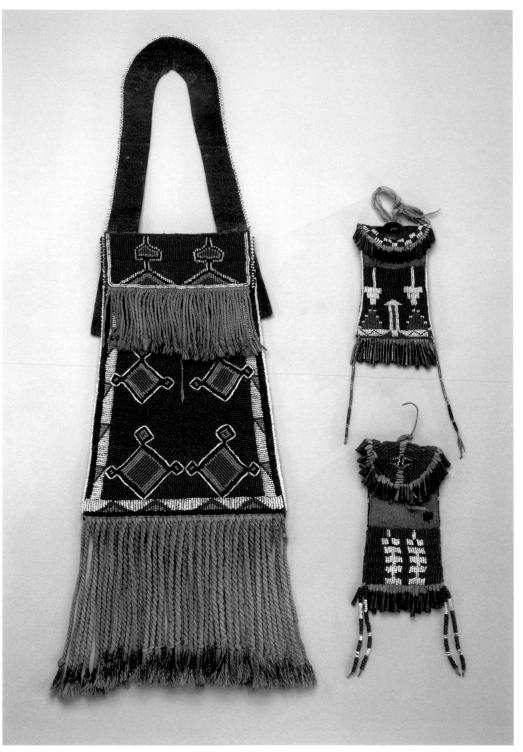

77. **Dispatch case, ca. 1880**

Southern Plains, Kiowa
Commercially tanned leather,
glass beads, cotton tassels; 10¼ ×
7½ in. (26 × 19 cm); strap: L. 16 in.
(40.5 cm)

78. **Belt pouch, ca. 1870**

Southern Plains, Kiowa
Native-tanned skin, commercially
tanned leather, glass beads, metal
cones and disk; 4⅛ × 2¾ in. (10.5
× 7 cm), excluding fringe

79. **Belt pouch, ca. 1880**

Southern Plains, Kiowa (?)
Commercially tanned leather,
glass beads, metal cones; 5 ×
2⅜ in. (12.7 × 6 cm), excluding
fringe

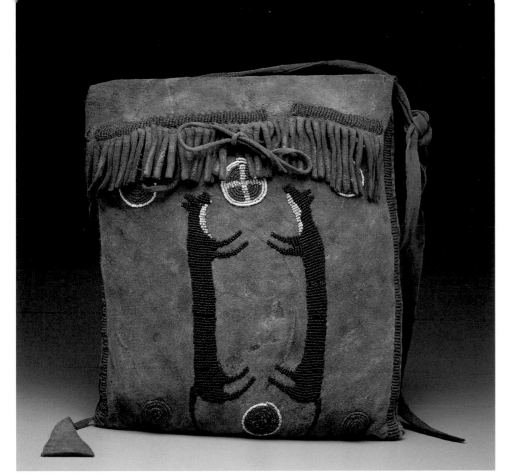

80. **Tobacco Society bag, ca. 1880**

Northern Plains, Crow
Native-tanned skin, glass beads;
11⅛ × 10⅞ in. (28 × 27 cm), excluding fringe; strap: L. 24¼ in. (61.5 cm)

81. **Saddlebag, ca. 1890**

Central Plains, Teton Sioux
Native-tanned skin, glass beads,
metal cones, horsehair tassels;
12½ × 17½ in. (31.8 × 44.5 cm),
excluding fringe
Published: Sotheby's (New York),
October 21, 1994, lot 161

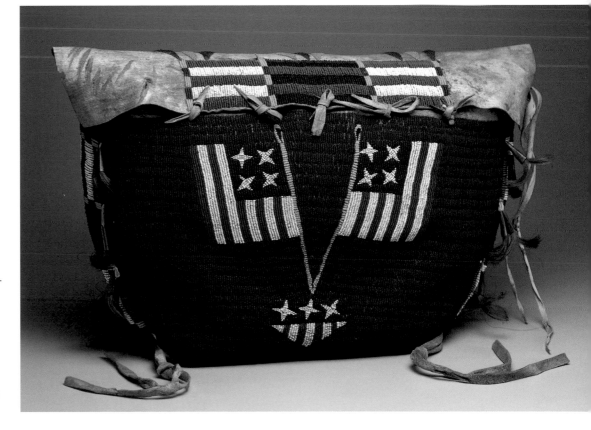

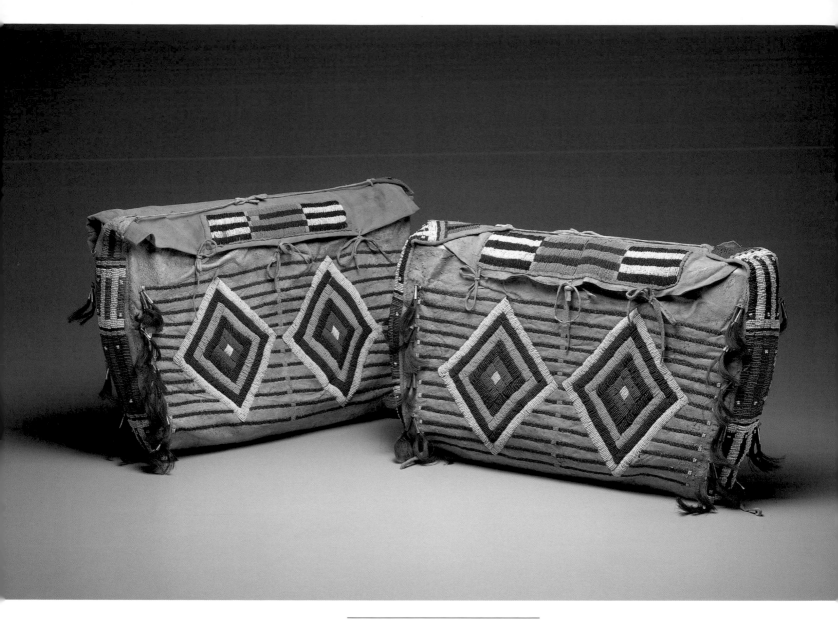

82. Pair of saddlebags, ca. 1880

Central Plains, Teton Sioux
Native-tanned skin, factory-woven
cloth, glass beads, metal cones,
horsehair tassels; 11¾ × 18½ in. (30 ×
47 cm) and 11 × 17¾ in. (28 × 45.1 cm)

83. **Pair of parfleches, ca. 1870**

Northern Plains, Blackfeet
Rawhide, pigment; 15 × 9⅞ in. (38 ×
25 cm) and 15 × 9½ in. (38 × 24 cm)

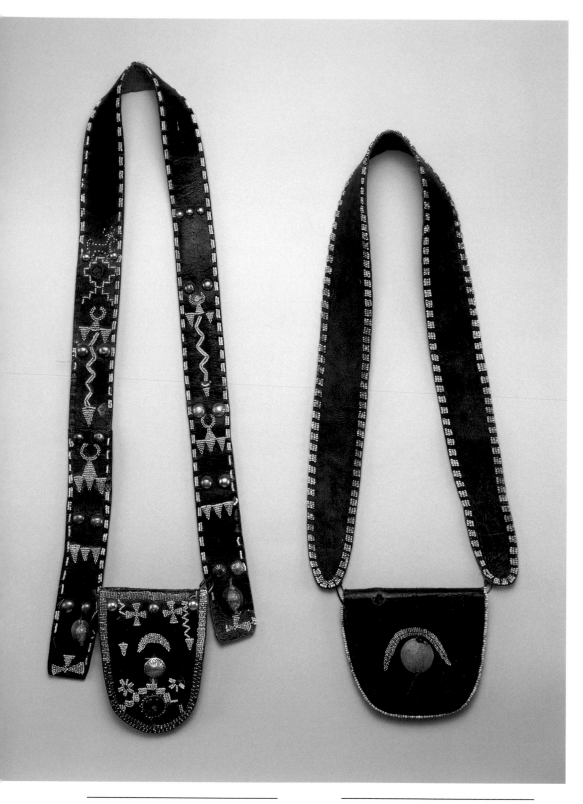

84. **Shoulder pouch, ca. 1870**

Southwest, Navajo
Commercially tanned leather, glass
beads, metal studs, shells; 6⅜ ×
4¾ in. (16.2 × 12.1 cm); strap:
L. 54½ in. (138.4 cm)

85. **Shoulder pouch, ca. 1870**

Southwest, Navajo
Commercially tanned leather, glass
beads, metal disk; 5¾ × 6½ in. (14.6 ×
16.5 cm); strap: L. 42 in. (106.7 cm)

Crafted from Nature: Kachina Dolls, Pueblo Pottery, and American Indian Baskets

Bruce Bernstein

Kachina Dolls

The Kachina are supernatural beings of the Pueblo villages of the American Southwest, where ceremonies frequently include appearances by these masked beings. There are over two hundred identified Kachinas, each bringing and sending different blessings for the villages. The Hopi Pahlik' Mana Kachina (cat. no. 87), for example, helps bring fertility; her *tablita* (headdress) represents clouds, and her abalone shell, water, while as a whole she symbolizes Hopi corn.

Kachina dolls representing these supernatural beings are particular specialties of the Hopi and Zuni. Each figure is thought to hold a portion of the spirit power belonging to the Kachina after whom it is fashioned. These figures are given to children as didactic objects to be treasured as part of their religious training. During the winter and summer ceremonial cycles, the Kachina themselves present the figures, which are cherished and hung on the wall at home, or from the rafters, where they will be in constant view of the children of the family and their playmates.

Carved of cottonwood, Kachina dolls are painted and dressed in the clothing, jewelry, feathers, and other attributes specific to each Kachina. Children learn to recognize the precise details of each doll and to understand their symbolic nature. The Hania, for example, is a male Kachina (cat. no. 86), as indicated by his warrior regalia—a snake kilt, wooden armlets, warrior's path across the eyes and warrior tracks above them, owl plumage on the back of the head, and a flint sharpener in his left hand. While the Hilili Kachina (cat. no. 89) is also male and is dressed similarly in a kilt and mask, he is more associated with the Zuni Harvest Dance.

Children also learn to distinguish between Kachina and Paiyakyamu, or the three climbing figures (cat. no. 88). These beings belong to societies often misleadingly translated as "clowns" in English. In fact, the Paiyakyamu embody the raw energy from which all life is formed. They teach villagers through their antics, often using humor to poke fun at human lives and frailties. Representations of climbing figures would also help the child to recognize some of the playful ways that the Paiyakyamu might appear in the village.

Pueblo Pottery

Pueblo pottery is one of the best known of North American Indian arts. Archaeologists suggest pottery was introduced from Mexico nearly two thousand years ago, but Pueblo oral traditions record that pottery was a part of the world as it was created.

Pueblo homes always include pottery as decoration; these pieces are often heirlooms as well as symbols of ethnic identity and sources of pride. Large jars (ollas) are used for storage of dried foods, clothing, and water; smaller ollas are used for cooking. Bowls are used for cooking, mixing, and raising bread dough, and for serving and eating stews. Bowls are also used as basins to hold the water to wash a young woman's hair before her wedding or an important ceremonial dance.

Today's potters work within traditions created over two millenia of continuity and change. As in most Native American Indian art forms, tradition is maintained in the act of creating the object, beginning with collecting the clay. Potters continue to dig their clays and tempers from locations that have been used for generations and subsequently passed on with the proper prayers by relatives. The clay is then cleaned, soaked, and cleaned again, removing small pebbles and other impurities and it is passed through a sieve. Pueblo pottery is made by the coiling method, not on the wheel. Most Pueblo potters are women; their hands and scrapers shape the piece as it is being built. The completed form is sanded and then slipped (coated with layers of a watery clay mixture). While still slightly damp, the slip is polished with a smooth stone. Colors, obtained from pigments that are either vegetal or mineral, sometimes a combination of both, are applied. After being painted, the pottery is ready for firing, which is generally done outdoors in open, aboveground fires fueled by wood and animal manure.

Southwestern pottery is diverse. Over the centuries literally hundreds of styles have emerged and disappeared. What we see today are the results of much experimentation and adaptation to diverse markets that include other Pueblo peoples, Hispanic villagers of the 1770s, and collectors of the 1990s. Change and flexibility are the constants of Southwestern pottery. The Socorro black-on-white storage vessel (cat. no. 98) dates from A.D. 1050 to 1100, a period of pottery making that was dominated by black-and-white geometric decoration. The Ako polychrome (cat. no. 94) and the Acoma and Laguna pots (cat. nos. 92, 93) were all made to hold and transport water. The Acoma and Ako pots were made at the same village, three generations apart. While the Ako pot interprets neighboring Zuni village's penchant for bird forms, the Acoma water jar is decorated with a realistic painting of pumpkins and grapes, clearly influenced by European-American decorative arts. The Laguna pot's painting is a combination of the curvilinear open flower forms, birds, and leaves, set in a pattern of panels interspersed with medallions; it is reminiscent of Zuni or Zia pottery styles.

The Hopi potter Nampeyo (cat. nos. 95, 96) and María and Julian Martínez of San Ildefonso Pueblo (cat. no. 97) are considered the master artists of the medium in the twentieth century. They proved their genius by bridging the

nineteenth-century types to create vibrant twentieth-century pottery. Their work responded to the non-Pueblo world while remaining firmly grounded in village pottery traditions. Nampeyo re-created the Sityatki pottery style (A.D. 1350–1600), reinterpreting the bird and feather symbolism on elegant shouldered jars that were also based on the ancestral wares. María and her husband, Julian, developed a new type of pottery. María's extraordinary mastery of potting technology is seen in her forms and polishing. Julian's surface decoration is based on his use of ancestral rock art designs. Together they furthered the art of Pueblo pottery. Over the past century, potters of the Southwest have continued to rely upon and interpret these styles.

American Indian Baskets

American Indian baskets have been recognized throughout the world for their beauty, quality of construction, and elaborate designs. Using four basic weave techniques—wickerwork, plaiting, twining, and coiling—American Indian artists created a variety of shapes that function as containers and trays of unsurpassed beauty and functionality.

Baskets were made from plant materials, principally young shoots or branches, and roots. They were harvested at the appropriate time of year to ensure the proper hue, strength, and size. Most Native American basket weavers were women who handed down the essential knowledge of techniques and materials through successive generations of female relatives. While a weaver worked within the confines of her tribe's basketry traditions, she also wove her own artistic hand into each basket, bringing change, innovation, and vitality to the art form over the centuries by introducing new designs, shapes, and materials. Each basket has the duality of being an identifiable product of a specific tribe as well as a creation of the individual artist. Individual hand is readily apparent, for example, in Elizabeth Hickox's weaving style (cat. no. 114) or in the obvious differences in the work of two Washoe contemporaries, Datsolalee (cat. no. 101) and Lizzy Toby Peters (cat. no. 100).

Tribal individuality is also apparent in baskets. While the need for certain types of baskets crossed tribal lines, the form these functional baskets took remained unique to each tribe. A Pomo basket (cat. no. 112), for example, and that of a Panamint-Shoshone (cat. no. 103) are visually dissimilar, although they serve the same purpose.

The plants used in the weaving of baskets were minimally altered, creating objects truthful to the landscapes and the materials. A weaver's honest use of materials in her art was paralleled by her equally attentive use and understanding of the landscape, where she carefully tended plants to ensure their good growth before they could be harvested. Following the paths of known and unknown ancestors onto the landscape was a sacred act, making the harvest of basket materials a powerful, prayerful activity, rich in meaning and symbolic

action. A weaver was part of the literal and figurative landscape through being a basket weaver. Understood in this way, baskets are part of the landscape rather than products of the landscape.

Keen observation reveals that a weaver painstakingly turned the harder bark of the plant to the outer surface of the basket to create a more even color and durable surface. Weavers along the Pacific Northwest Coast, for example, split the spruce root into three sections—inside, middle, and outer root. Each layer possesses a particular sheen and hardness. Women used the soft inner portion of the root for work baskets, and the high-gloss outer surface for fancy baskets. Chemehuevi women from the Colorado River area would use several different species of willow to create subtle shades of tan and white, developing background, shading, and foreground in their otherwise stark black and white baskets. The Apache weaver used red yucca root to overcome the monochromatic black and white of her olla (cat. no. 99). The weaver of the Tubatulabal jar (cat. no. 108) used cladium root as her primary background color and a brighter split sumac shoot as a highlight around the pattern. This draws the eye to the symmetry and depth of the design.

To make such fine-tuned uses of plants, a basket weaver had to have a comprehensive understanding of the plant world as it relates to taxonomies. She would know what long-term effects her preparation of basket materials would have on the finished work.

Baskets could also possess an ever-evolving combination of weaving techniques. In the Tlingit hat (cat. no. 117) three weaving techniques create surface texture, form, and utility. Datsolalee's coiled bowl (cat. no. 101) exemplifies the minute attention to detail necessary to create a spiraling surface of interlocking stitches that resonates with the shape of her closed-mouth bowl.

The weaver used simple tools to transform plant materials into art. She wielded a knife to harvest plant shoots, and a digging stick, tire iron, or shovel to gather the roots of the water plants she used. Hours were spent trimming and cleaning materials with a simple kitchen knife or pocketknife. Finally an awl was used in coiling, to make a hole for the threads to be passed through. There were no design templates except in the weaver's mind.

Today's weavers often shortcut the harvest and proper preparation of materials by using freshly cut shoots before they are aged and dried. The result is uneven color and twisted and split stitches. In the past, when a weaver lacked the time for or interest in harvesting her own materials, she might find someone to trade with for basket materials to maintain the high quality of her work. Other weavers stopped weaving altogether rather than make a basket from inferior or different materials or of traditional materials harvested from a new location.

Before 1890 baskets were almost exclusively made for Native American use, but by the end of the nineteenth century were being made to fit the growing Indian art market. The Chicago world's fair of 1892 had helped acquaint the world with Indian baskets, and baskets were in such demand that by 1900 collectors and curators were complaining that the supply had been depleted and that weavers were no longer making traditional baskets. Through the 1890s until

Detail of cat. no. 101. Datsolalee (Louisa Keyser). Bowl, 1907.

about 1920, impressive public and private collections were made. These baskets in turn helped create an interest in Indian people, the West, and American Indian arts and crafts. As a result people began visiting the West, learning about Indian cultures, and collecting Indian art.

This Indian art market fundamentally changed the Native American art of basket weaving. Removed from the labor-intensive task of creating culinary wares for their households, the weavers were freed from some of the conventions and constraints of traditional weaving. In addition, metal knives for trimming, tin can lids for sizing, and steel awls for sewing made weaving easier and freed women from constantly needing to sharpen their awls.

During this period new basket styles were developed specifically for a non-Indian market. The Tlingit whale bowl (cat. no. 116) perfectly combines the weaving and aesthetic canons of Tlingit weaving with the newness of rendering a realistic whale. The Chumash bowl (cat. no. 104) is a rare example of this synergistic

relation of the weaver's traditional world, as well as her fascination with the European world. Working in the first quarter of the nineteenth century, weaver Lapulimeu faithfully copied a colonial Spanish coin. Nonetheless, the bowl was unmistakably woven in the Chumash style. The rendering of the coin is unique because of its rarity and the use of realism at this early date. The individuality of a weaver's work is quickly apparent when comparing this bowl to the Chumash olla (cat. no. 109). Both pieces are made in the same technique and of the same materials, yet visually they might seem dissimilar.

Elizabeth Hickox (cat. no. 114), Lucy Telles (cat. no. 102), Datsolalee (cat. no. 101), and Lapulimeu (cat. no. 104) all made unsurpassed masterpieces. Interestingly, each of these baskets also provides a glimpse of the weaver's understanding of the non-native's appreciation of American Indian baskets and longing for the world that created them. The fact the weavers developed such a highly specialized and patron-specific art, while rarely, if ever, having more than cursory knowledge of the patron's world, exemplifies how much we enter the world of the weavers when we appreciate their baskets.

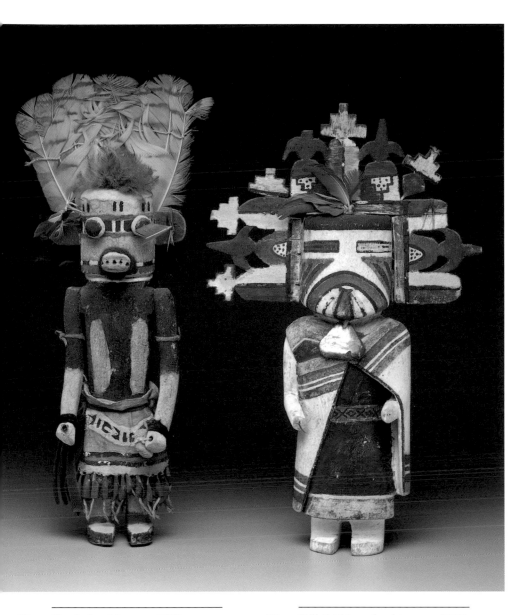

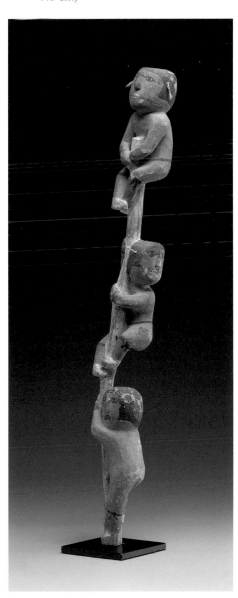

88. Three Paiyakyamu, ca. 1900

Southwest, Hopi
Wood, pigment; 20¼ × 3 in. (51.4 × 7.6 cm)

86. Hania kachina, ca. 1920

Southwest, Hopi
Wood, pigment, factory-woven cloth, feathers, metal cones, stone; 16 × 3¾ in. (40.6 × 9.5 cm)

87. Palhik' Mana kachina, ca. 1895

Southwest, Hopi
Wood, pigment, feathers, shell; 15 × 9¼ in. (38.1 × 23.5 cm)

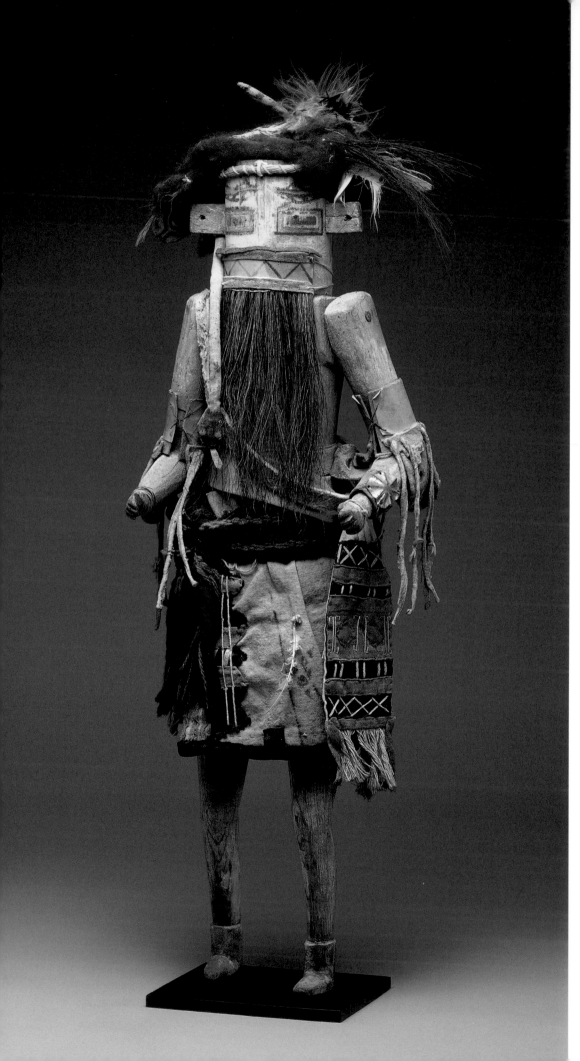

89. Hilili kachina, ca. 1890

Southwest, Zuni
Wood, native-tanned skin,
factory-woven cloth, paper,
pigment, feathers, horse-
hair, plant fiber, wool yarn,
metal, shell; 18 × 6½ in.
(45.7 × 16.5 cm)
Published: Coe 1977,
no. 719a
Ex coll.: Proctor Stafford,
Los Angeles, Calif.

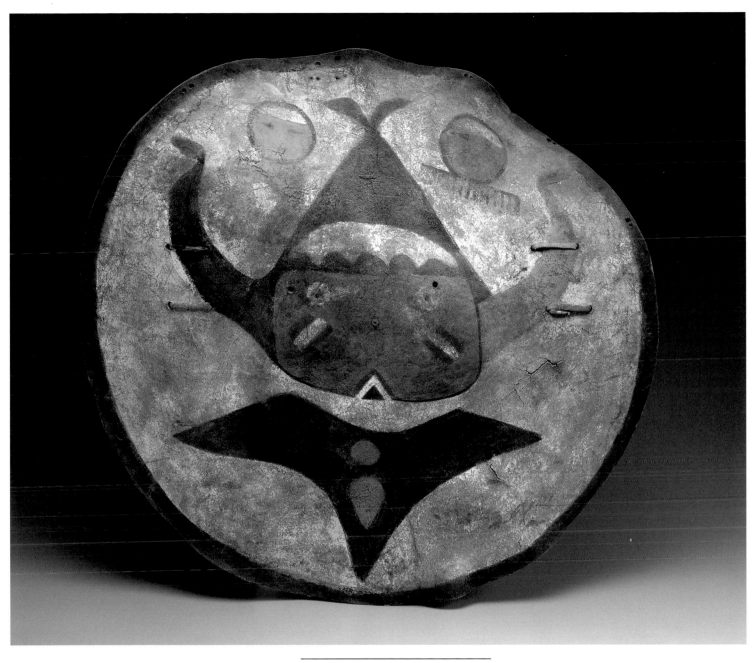

90. Shield, ca. 1860

Southwest, Acoma Pueblo
Rawhide, pigment; 3 × 21 in. (7.6 ×
53.3 cm)

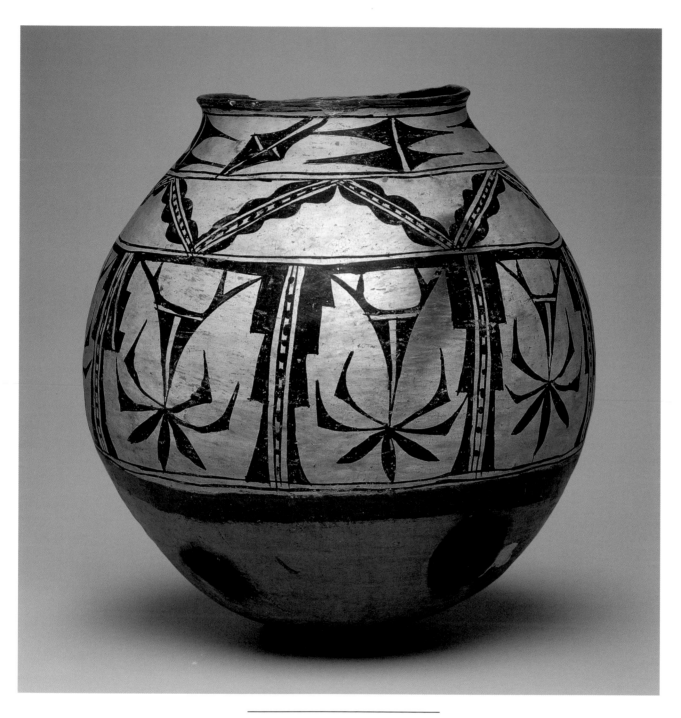

91. Storage jar, ca. 1790

Southwest, Tewa
Powhoge polychrome ceramic; 19 ×
16⅝ in. (48.2 × 42.3 cm)

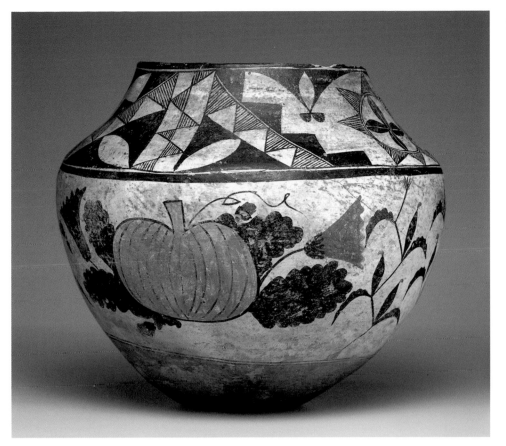

92. Jar, ca. 1900

Southwest, Acoma Pueblo
Polychrome ceramic; 9⅞ ×
11¼ in. (25.0 × 28.6 cm)
Published: Frank and Harlow
1974, pl. 24
Ex coll.: Larry Frank, Arroyo
Hondo, N.M.

93. Jar, ca. 1890

Southwest, Laguna Pueblo
Ceramic; 9¾ × 9¼ in. (24.8 ×
23.5 cm)

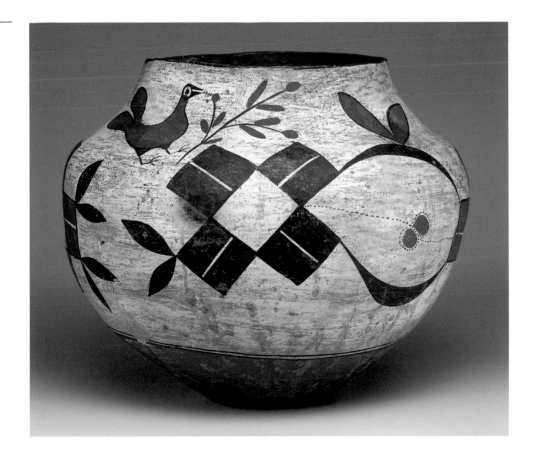

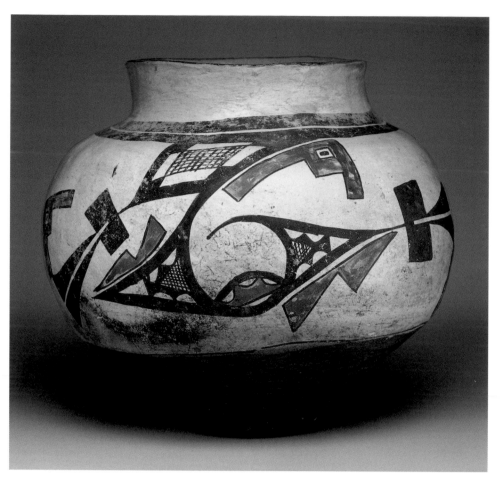

94. Jar, ca. 1770

Southwest, Acoma Pueblo
Ako polychrome ceramic; 10½ ×
11½ in. (26.8 × 29.3 cm)

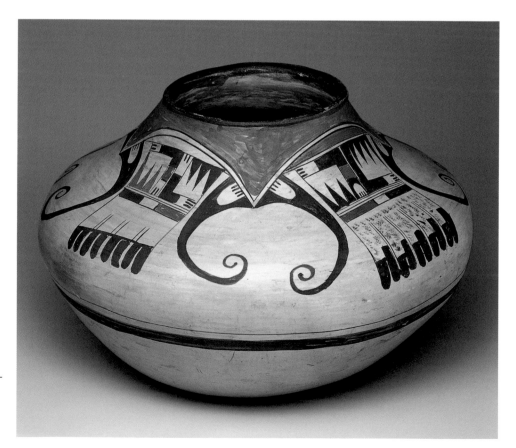

Nampeyo

Southwest, Hopi-Tewa, 1860?–1942

95. Jar, ca. 1895

Ceramic; 8½ × 12⅛ in. (21.5 ×
30.8 cm)

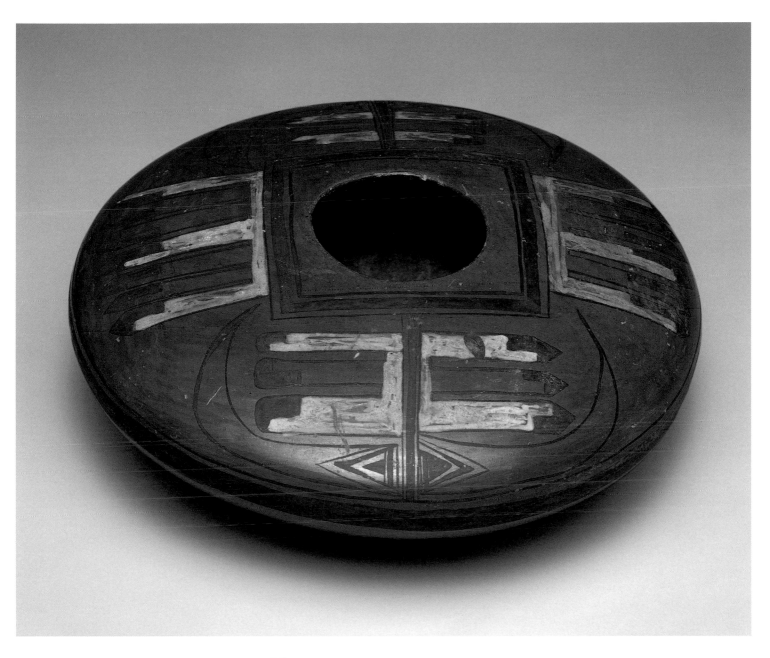

Nampeyo
Southwest, Hopi-Tewa, 1860?–1942

96. Jar, ca. 1905

Ceramic; 3⅝ × 8¾ in. (9.2 × 22.2 cm)

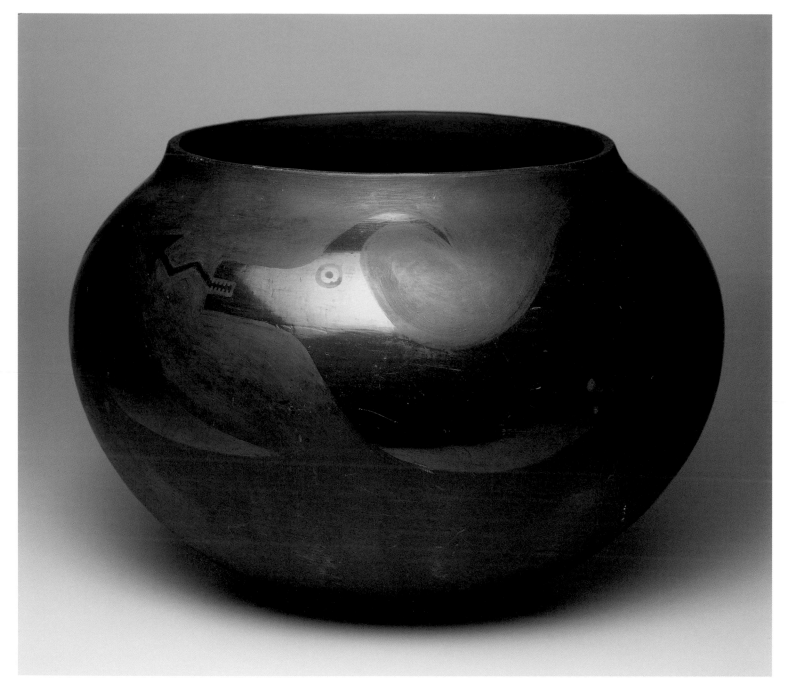

María and Julian Martínez

Southwest, San Ildefonso Pueblo, 1887–
1980 and 1885–1943

97. **Jar, 1919–20**

Black-on-black ceramic; 9⅞ × 14⅝ in.
(25.1 × 37.2 cm)
Ex coll.: Rick Dillingham, Santa Fe, N.M.

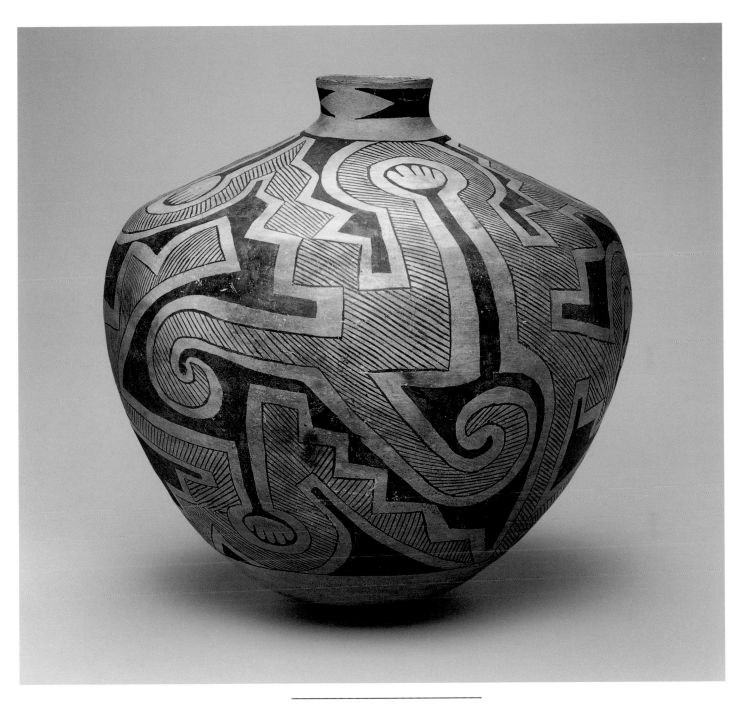

98. **Storage jar, ca. 1050–1100**

Southwest, Socorro
Black-on-white ceramic; 15⅛ ×
15⅞ in. (38.4 × 40.3 cm)

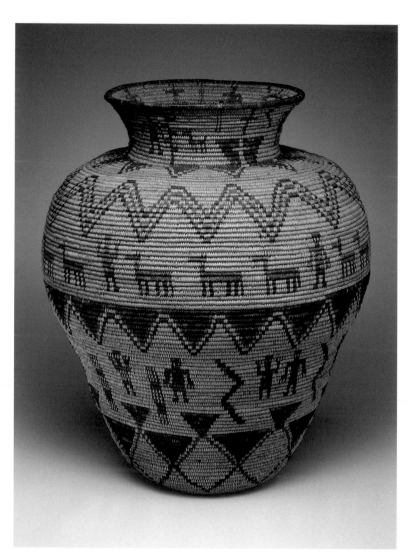

Storage basket, ca. 1900

Southwest, Western Apache
Willow, devil's claw, yucca root on
three-rod foundation; 20⅝ × 17½ in.
(52.4 × 44.5 cm)

Lizzy Toby Peters

Great Basin, Washoe, 1868?–1943

100. **Bowl, ca. 1904**

Willow, redbud, bracken fern
root on three-rod foundation;
7⅛ × 11¼ in. (18.2 × 28.6 cm)

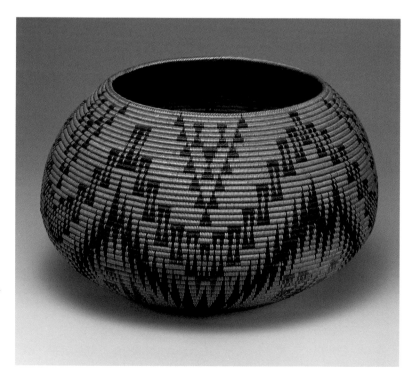

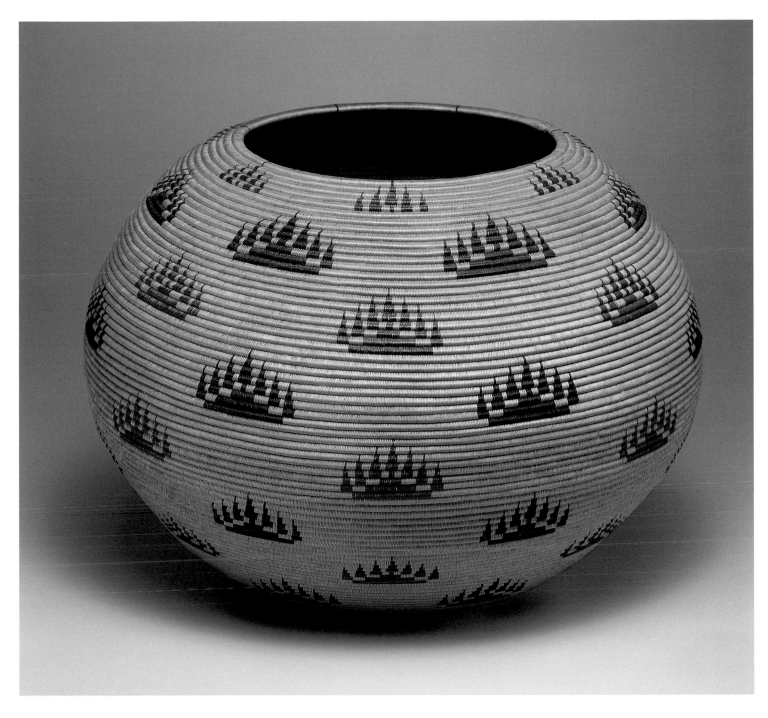

Datsolalee (Louisa Keyser)

Great Basin, Washoe, 1850?–1925

101. Bowl, 1907

Willow, western redbud, bracken fern root on three-rod
foundation; 12½ × 16⅝ in. (31.8 × 42.2 cm)
Published: Cohodas 1976, fig. 21; Parke-Bernet (New
York), November 19, 1971, lot 138
Ex coll.: The Emporium Company, Carson City, Nevada,
44LK, 1906 (?); George C. Green Family Collection;
Jerrold Collings, Ariz.

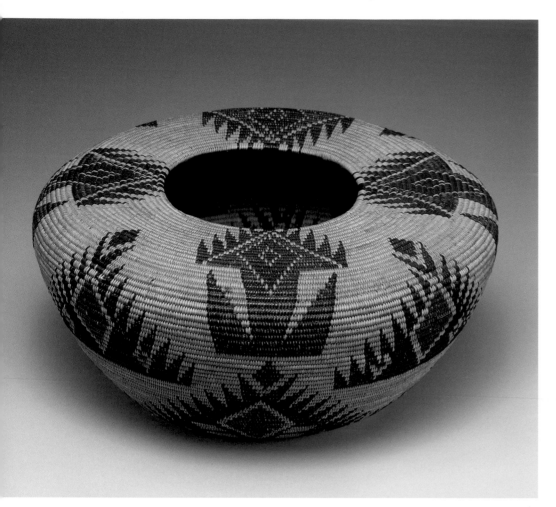

Lucy Telles
Central California, Miwok Paiute, 1885–1955

102. Shouldered bowl, ca. 1912

Sedge root, redbud, bracken fern root on three-rod foundation; 5 × 9⅞ in. (12.9 × 25.1 cm)
Published: Bates and Lee 1990, p. 84, fig. 159, no. 29
Ex coll.: For sale in Nelson Salter's store, Yosemite Valley, ca. 1912

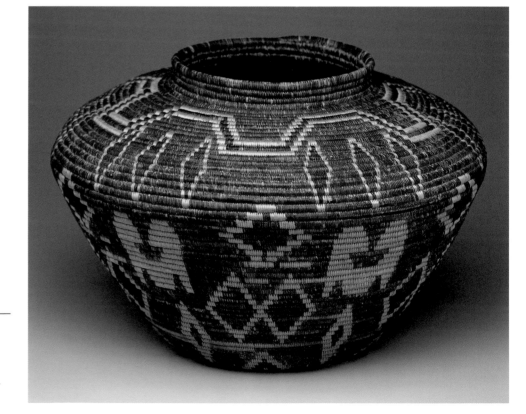

103. Shouldered jar, ca. 1910

Great Basin, Panamint-Shoshone
Yucca root, devil's claw, sumac on three-rod foundation; 7⅝ × 11¼ in. (19.5 × 28.5 cm)

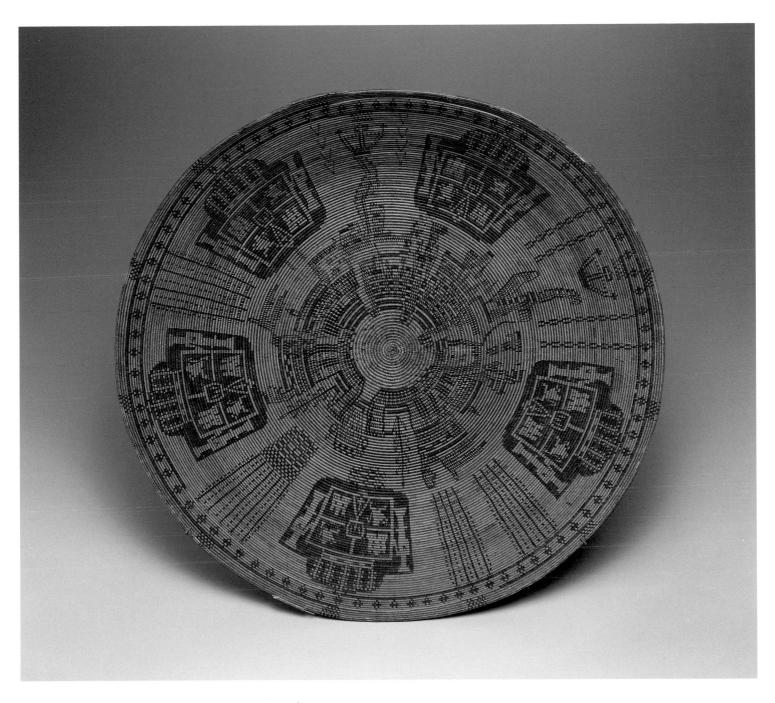

Lapulimeu

Central California, Chumash, 1767–after 1820

104. Coin bowl, ca. 1820

Split natural and dyed juncus stems,
sumac on three-rod juncus foundation;
4¼ × 18⅜ in. (10.8 × 46.7 cm)

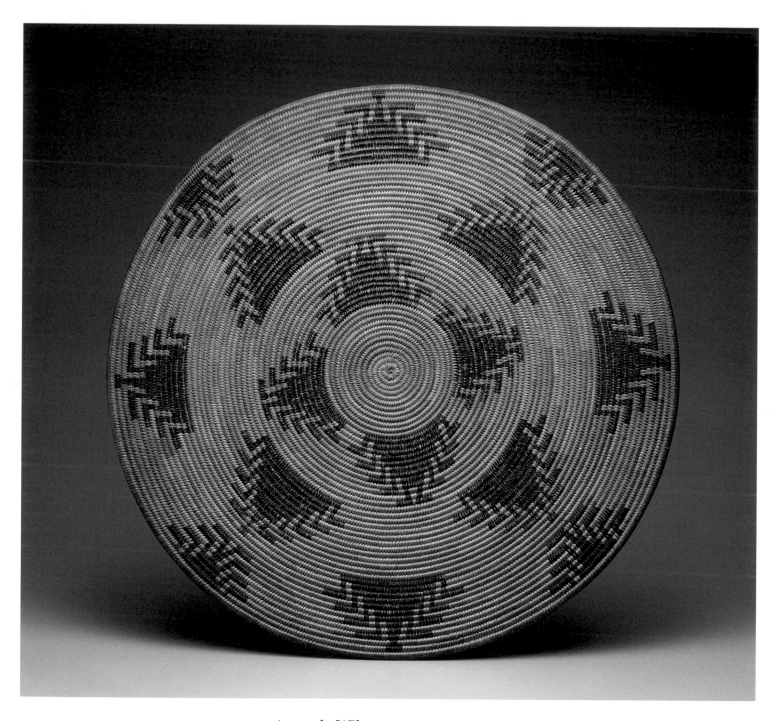

Amanda Wilson

Central California, Konkow Maidu, 1864?–1946

105. Sifting tray, ca. 1930

Sedge root, briar root on three-rod
foundation; ¼ × 15½ in. (.6 × 39.5 cm)
Ex coll.: Anna Belle Sexton, Chico, Calif.

Lucy Makil

Southwest, Pima, d. after 1930

106. Tray, ca. 1930

Willow, devil's claw on cattail bundle
foundation; ⅝ × 13⅞ in. (1.8 × 34.5 cm)
Ex coll.: Bert Robinson, Sacaton, Ariz.

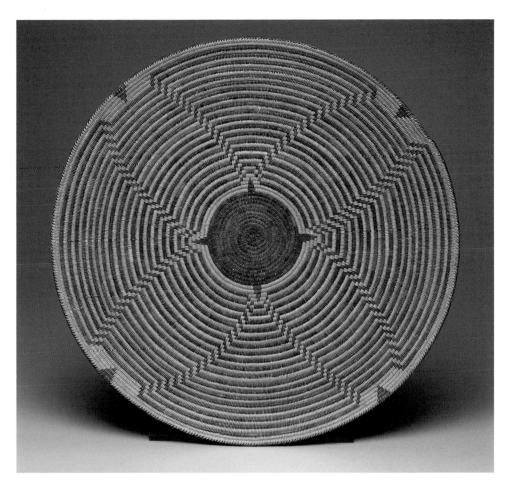

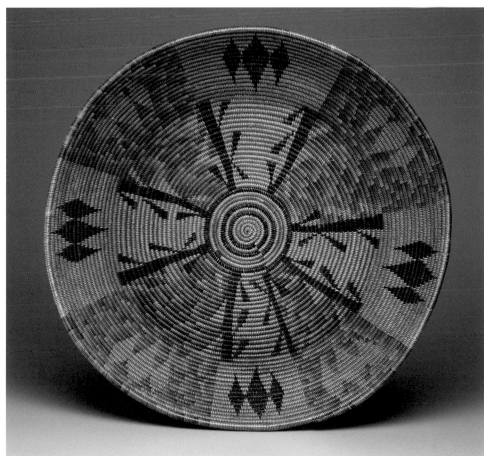

107. Tray, ca. 1910

Southern California, Desert
Cahuilla
Sumac, dyed and natural
juncus on deer-grass bundle
foundation; 3½ × 18⅜ in.
(8.8 × 46.7 cm)
Ex coll.: Claire Zeisler,
Chicago, Ill.

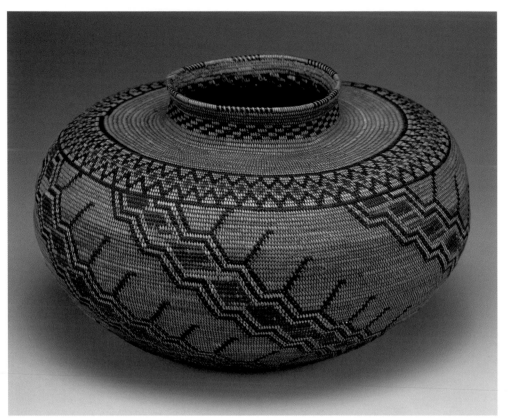

108. Jar, ca. 1880

Southern California, Tubatulabal
Cladium root, bracken fern root,
yucca root, sumac on bundle founda-
tion; 5⅜ × 8⅝ in. (13.6 × 22 cm)

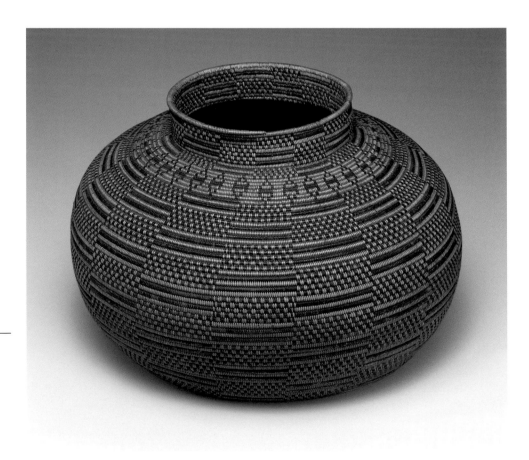

109. Jar, ca. 1790

Central California, Chumash
Sumac, dyed sumac on foundation
of three juncus stems; 6⅛ × 8⅜ in.
(15.7 × 21.4 cm)
Published: Maurer 1977, pl. 387
Ex coll.: Claire Zeisler, Chicago, Ill.

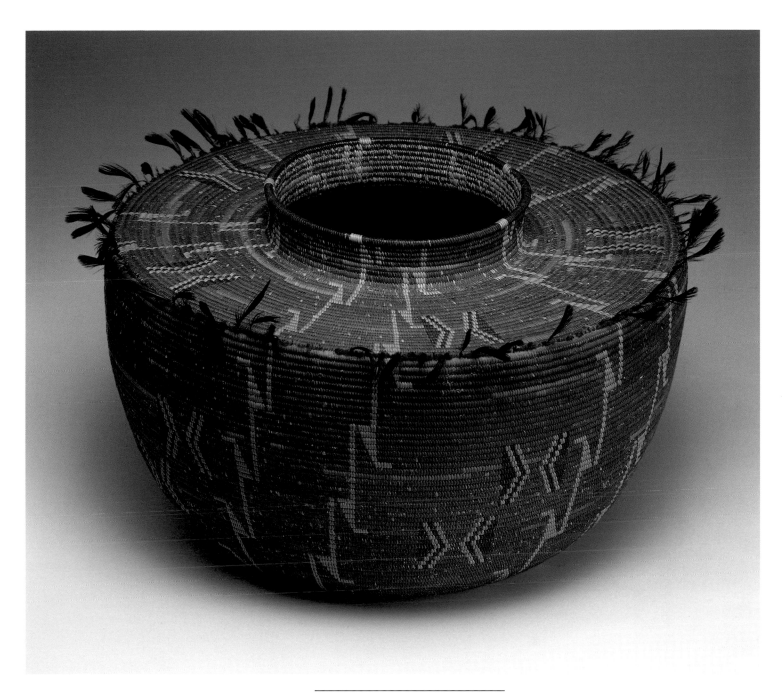

110. Shouldered jar, ca. 1880

Southern California, Tejon or
Panamint-Shoshone
Yucca root, devil's claw, sumac on
three-rod foundation; quail topknot
feathers, acorn woodpecker feathers;
5¾ × 9¼ in. (14.5 × 23.4 cm)

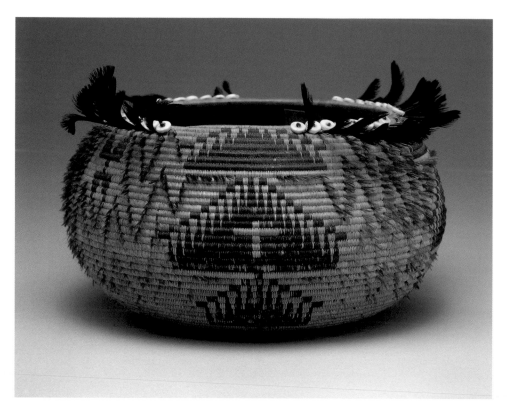

111. Bowl, ca. 1890

Central California, Central Pomo
Sedge root, bulrush root sewn on three-rod foundation; acorn woodpecker feathers, quail topknot feathers, clamshell and glass beads; 3½ × 6½ in. (9 × 16.5 cm)

112. Gift basket, ca. 1860

Central California, Pomo
Sedge root, bulrush root sewn on three-rod foundation; acorn woodpecker feathers, quail topknot feathers, glass beads; 4½ × 9½ in. (11.5 × 24.2 cm)
Published: Bates 1982, p. 30, fig. 4
Ex coll.: James H. Schwabacher, San Francisco, Calif.

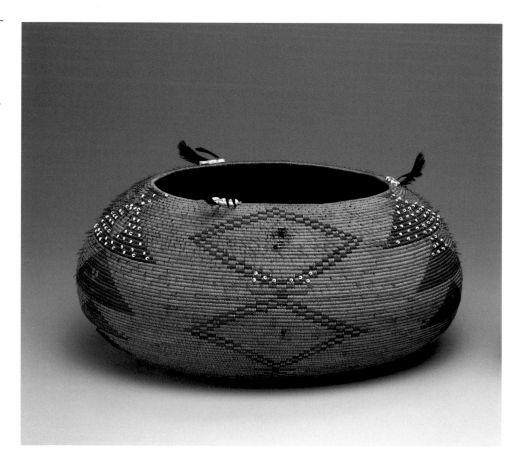

113. Gift basket, ca. 1850

Central California, Wappo or
Southern Pomo
Sedge root, bulrush root on single-
rod foundation; clamshell and glass
beads, quail topknot feathers; 3 ×
6¾ in. (7.5 × 17 cm)
Ex coll.: G. A. Steiner Collection,
Pittsburgh, Pa.

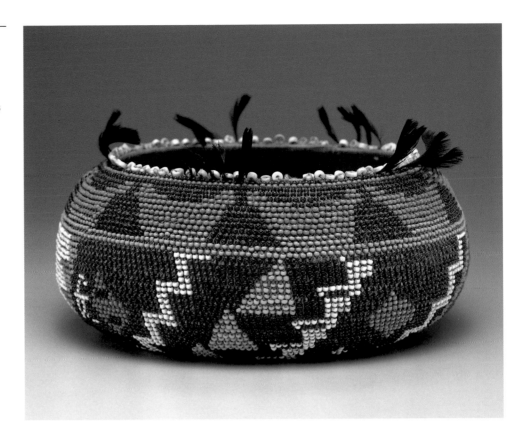

Elizabeth Hickox

Northern California, Karok, 1873–1947

114. Gift basket, ca. 1910

Conifer root, maidenhair fern stems,
bear grass on hazel stick warps; 7⅛ ×
8¼ in. (18 × 21 cm)
Ex coll.: Grace Nicholson, Pasadena,
Calif., cat. no. 6632

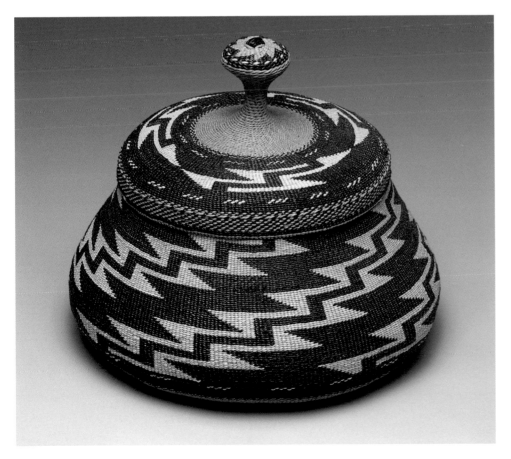

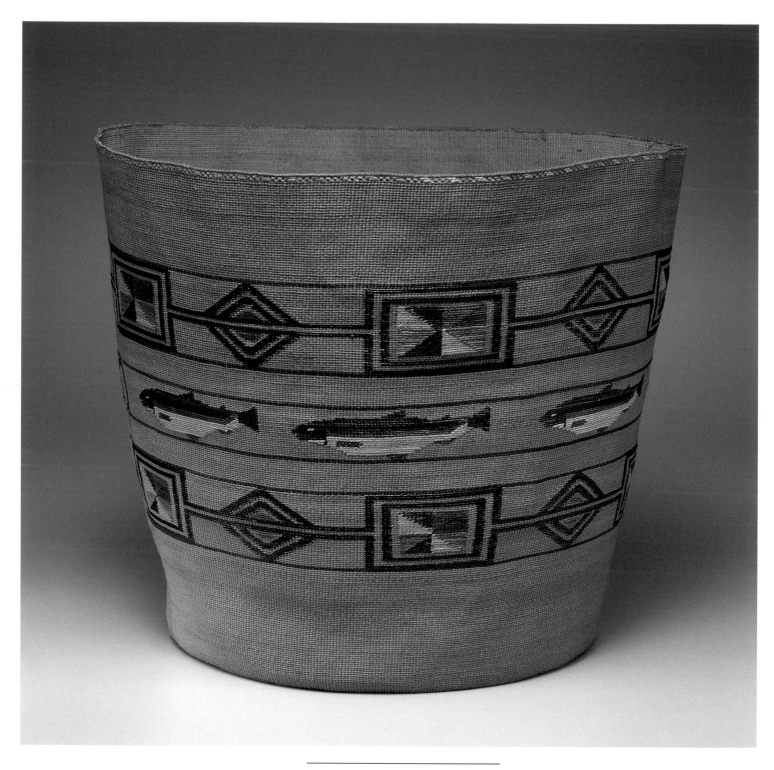

115. Salmon basket, ca. 1910

Pacific Northwest, Tlingit
Plant fiber; 11⅛ × 14⅜ in. (28.3 × 36.5 cm)

116. Killer-whale basket, ca. 1910

Pacific Northwest, Tlingit
Plant fiber; 13⅞ × 15⅞ in. (34.7 × 40.2 cm)
Ex coll.: G. A. Steiner Collection, Pittsburgh, Pa.

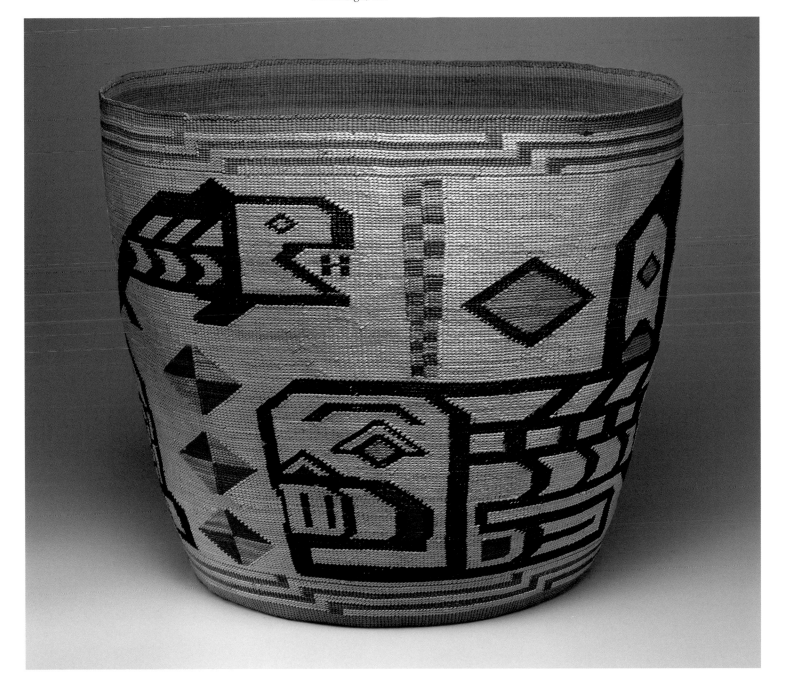

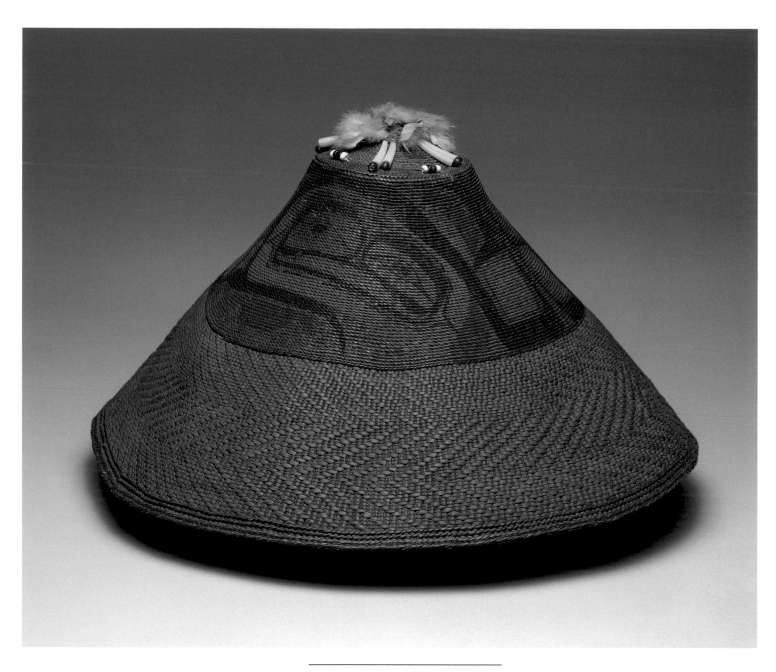

117. Basketry hat, ca. 1830

Pacific Northwest, Tlingit
Plant fiber, pigment, shells, glass
beads, fur; 6¾ × 12⅛ in. (17 ×
30.8 cm)

An Important Third Dimension: American Indian and Eskimo Sculpture

Allen Wardwell

The Plains and Woodlands

As John Ewers states in his groundbreaking study, *Plains Indian Sculpture*, most influential scholars who worked with the art of the Plains Indians during the first half of this century largely ignored or even derided the rich carving traditions that existed there. While the three-dimensional works of the Woodlands Indians may have fared somewhat better in the studies of the time, there has still been a tendency among those less familiar with the art to regard it as being mostly two dimensional and essentially utilitarian in nature. Fortunately, more recent scholarship and the interests of museums and such collectors as Charles and Valerie Diker have served to correct these misconceptions. Certainly examination and study of the examples shown here reveal a wealth of exceptional sculptural artistry and skill.

The woodwork creations of the Woodland Indians are introduced through a variety of prestige eating utensils and drinking vessels that proclaimed the discernment and status of their owners. This concept is well represented here by the belt cup (cat. no. 138) with its beautifully carved bowl showing relief designs of beavers and northern pike and a fully realized beaver figure on the handle. In the same tradition is the Menominee burl ladle (cat. no. 136) with its openwork silver ornament depicting a beaver in profile. The tradition of making finely carved eating implements is found elsewhere, among other groups, including those of the Northwest Coast (cat. no. 137), the Eskimo, and the California peoples, who produced the Hupa elk horn spoon (cat. no. 135) with its elegantly serrated handle.

While such objects as these might be categorized as applied or decorative arts, they also reveal that the Woodland Indians were superb sculptors who could work in the round. A high level of skill is evident in the conception and quality of the pipe bowl in the form of a crouching figure (cat. no. 139). It is a rare survival from the late eighteenth century and attributed to the central Algonkian peoples of the Great Lakes region. Not only is it a fully realized rendering of the human form, but it also shows careful attention to detail, particularly in the carving of the hands and facial features.

Pipes with their carved stone bowls and intricately worked stems are also among the best-known examples of three-dimensional art from the Plains

Indians. Such pipes were smoked in ceremonial and social contexts from prehistoric times. In the Diker Collection this type is represented by a Sioux effigy pipe (cat. no. 65) with a twisted spiral shaft showing a bird's head in relief to indicate the spirit associated with the man who owned the pipe. It is equipped with a stone catlinite bowl with lead inlays applied in typically geometric patterns. Another notable type of Plains Indian sculpture is found on the courting flutes that were played by men as they sought to attract the attentions of young women. The single tone that was sounded appropriately imitated the mating song of a waterbird, the head of which was carved at the end. The elegant Diker example (cat. no. 64) may represent a snipe or a crane. Certain objects associated with horse riding, such as the handles of quirts, were also carved in human and animal forms. Some take simple shapes, such as the Mesquakie example with its colored geometric relief designs (cat. no. 63).

Sculpture from the West and Northwest Coasts

The sculptural creations of the coastal areas have never suffered the neglect that has been accorded three-dimensional creations of the Woodlands and Plains Indians. The Northwest Coast Indians are renowned for their mastery of plastic form and for the skill with which they combine the principles of sculpture and two-dimensional design. The graphic quality of this expression is well represented by the Haida ceremonial tunic (cat. no. 127), which was probably made for the child of an important chief to be worn at winter ceremonies. It is in the shape of family crests of a flying bird. Painted curvilinear designs represent frontal and profile faces and the flowing oval and U-shaped motifs that are so characteristic of this art.

The three-dimensional works of art in this area of the Diker Collection show an interesting progression from the angular and geometrized formulas of the southern styles to the more complex curvilinear art of the northern groups. With its smooth, unadorned surfaces, the Chinook ladle (cat. no. 133) is a fine representative of the southern aesthetic. This sense of pure form is also found in the handle with two bird heads, the shapes of which have been reduced to their essentials. Human-figure sculpture from this part of the coast is introduced by the bone Wishram figure of the late prehistoric period (cat. no. 134). Rectilinear, chevron, and circular engraved patterns on the body and headdress are reflected in the angular shapes of the shoulders, feet, headdress, and apron. Similar details can be noted in the ornamentation of the handle of the Salish comb (cat. no. 132) and the rigid geometric conception of the human figures and the heads in relief.

Moving north along the coast into British Columbia and southern Alaska, the collection provides a view of Northwest Coast three-dimensional work, both from the standpoint of style and as a representation of some of the characteristic object types from the area. Here the sculpture shows a more fluid line, and combinations of anatomical elements representing human and animals in complex

interrelationships are depicted. Much Northwest Coast art in the Diker Collection was made to be shown at occasions that proclaimed and validated the status of, and crests owned by, powerful families. Many objects associated with winter feasts, known as potlatches, serve this purpose and include clothing laden with painted or woven imagery and carved ornaments that were worn by members of such families. A Haida frontlet representing the mythical Dogfish Woman is one of the latter (cat. no. 122). The Tlingit mountain goat–horn spoon (cat. no. 137), the handle of which represents a miniature totem pole carved with crest imagery, would constantly remind the user of the prestige and background of his host during potlatches. The unusually carved underside of the bowl also depicts an animal totem associated with a powerful family. The relief designs on the mountain sheep–horn serving bowl (cat. no. 128) served similar functions. When they were used, stories were told, songs sung, and dances performed to reinforce the prerogatives that were being claimed.

Rattles and other instruments accompanied these displays, and they were carved and painted with crest imagery. The double-headed Bella Bella round rattle (cat. no. 126) was used in such a context, and the faces carved on both sides may represent some celestial imagery associated with the sun and the moon. Raven rattles were used at potlatches all along the coast, and the fine old Tlingit example in the Diker Collection (cat. no. 124) is typically conceived, with its depiction of a shaman figure reclining on the raven's back, his tongue extended to the mouth of a frog. Another bird, perhaps a hawk, is carved on the bottom. A more unusual rattle form also seen here is the Tlingit example with a bird on the back, which perhaps represents a duck or a grebe (cat. no. 125). During some potlatch ceremonies, bird down was scattered about when a story had been completed or a particularly dramatic moment in a performances had been reached. The Haida sometimes used a type of whale-tooth ivory container (such as cat. no. 131) to hold the down. This one is inlaid with abalone shell and beautifully carved in the form of a raven head with a smaller hawk head carved at the rear.

Two objects associated with the all-important salmon harvest may also have been used during a potlatch. One is a Tlingit headdress showing a maskette attached to a square openwork framework that represents a fish trap (cat. no. 121). It is related to an example in the Harriman Collection at the American Museum of Natural History, New York, which is catalogued with the information that it was "used in public performances to act out myths and stories." A Nuu-Chah-Nulth dance accessory in the form of a fish trap with a whole school of salmon suspended from its framework (cat. no. 120) could well have been used in the same way. Alternatively, it might have been manipulated by a shaman during ceremonies to bring about a successful harvest.

Three objects in the Diker Collection are unquestionably associated with shamanic performances. At these, certain types of masks, rattles, and other implements were worn or carried by a practitioner during healing rituals and at other times when it was necessary to communicate with the supernatural world to bring about other benefits to the community. Tlingit shamans wore masks to impersonate the spirit helpers in their service. The bear mask in the Diker

Collection (cat. no. 123) is shown with the lips open and pursed to denote chanting or speaking, and the eyes are not pierced, so that the spirit could inhabit the shaman without any interference from the human world. Shamans also wore ivory, bone, or antler pendants suspended from their necks or other parts of their costume. As with the example in the Diker Collection (cat. no. 130), many are intricately carved with animal and human figures to illustrate the dreams experienced by the shaman during his vision quests. On this pendant are a killer whale with a reclining figure in a trance at the rear, a seated figure at the top, and three spirit faces. The Tsimshian bone soul catcher (cat. no. 129) is another neck ornament used by the northern shaman. When he was treating a patient whose illness was thought to have been brought about by the departure of his soul, the shaman would seek to recapture it in such a receptacle. Upon its successful return, a cure would result.

The Eskimo

The abundant shamanic art from the northern Northwest Coast, particularly that of the Tlingit, may owe some of its inspiration to influences from the Yup'ik Eskimo of the Yukon-Kuskokwim river delta of Alaska. The creation of shamanic paraphernalia reached spectacular heights here, and each object is a unique expression made to fill a specific need and to tell its own story. The dance ornament (cat. no. 119) is such an object. It shows an Eskimo hunter capturing a walrus from his kayak, which itself has been conceived to take on the features of a walrus, thus connecting the hunter to the spirit of his prey. It was probably worn during a ceremony recounting an event in a specific hunter's life or his mythical past.

Of equal interest and quality is the Hooper Bay mask (cat. no. 118) that was worn in winter dances to please the animal spirits and thus assure successful hunting in the coming season. It was worn by a shaman and represents the contents of a long-forgotten dream. Again, it takes the form of a kayak with a seal head in the center, seal flippers at the bottom, salmon spirits at the top on both sides of a skull-like head, and human hands at the sides. The result is a highly creative combination of sculptural elements that give homage to spirits essential to successful hunting. The mask was therefore associated with rituals that assured survival.

Taken as a whole the important sculptural objects in the Diker Collection present a microcosm of American Indian custom, ritual, and belief. While some of the secular objects in the collection were made simply to be expressions of beauty in and of themselves and to indicate something of the status of their owners, other objects served as paraphernalia for important religious or social ceremonies. They functioned as vehicles for communication with the supernatural world. Still others are associated with performances that were essential to the survival and health of the people.

118. **Mask, early 1900s**

Arctic, Yup'ik Eskimo
Wood, pigment, feathers;
33⅞ × 23½ in. (86 × 59.7 cm)
Published: Sotheby's (New York), December 3, 1993, lot 207
Ex coll.: Museum of the American Indian, Heye Foundation, New York, N.Y., no. 5/2777

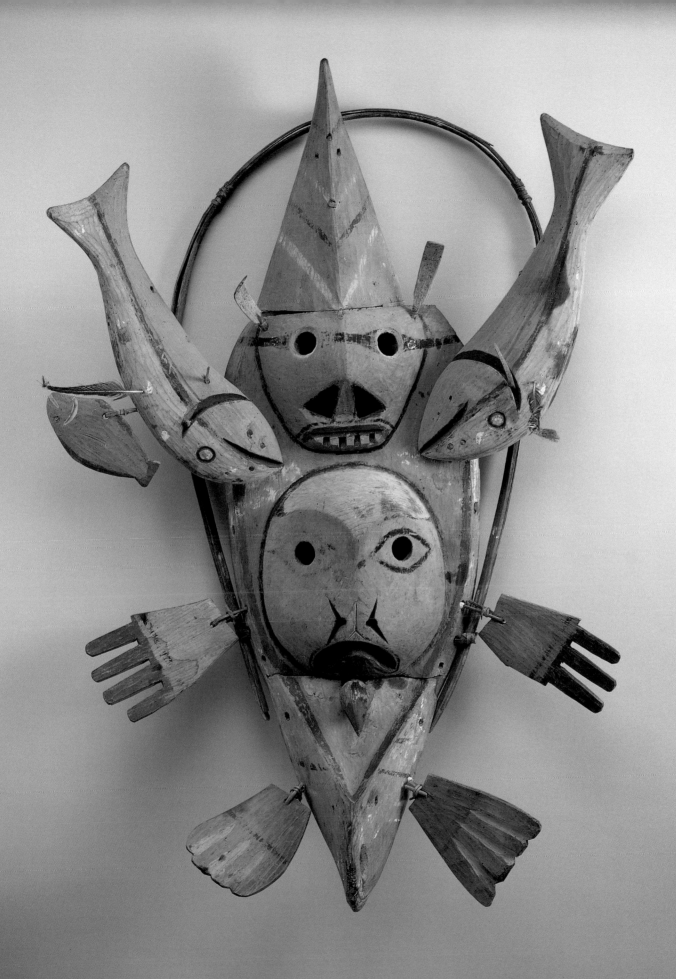

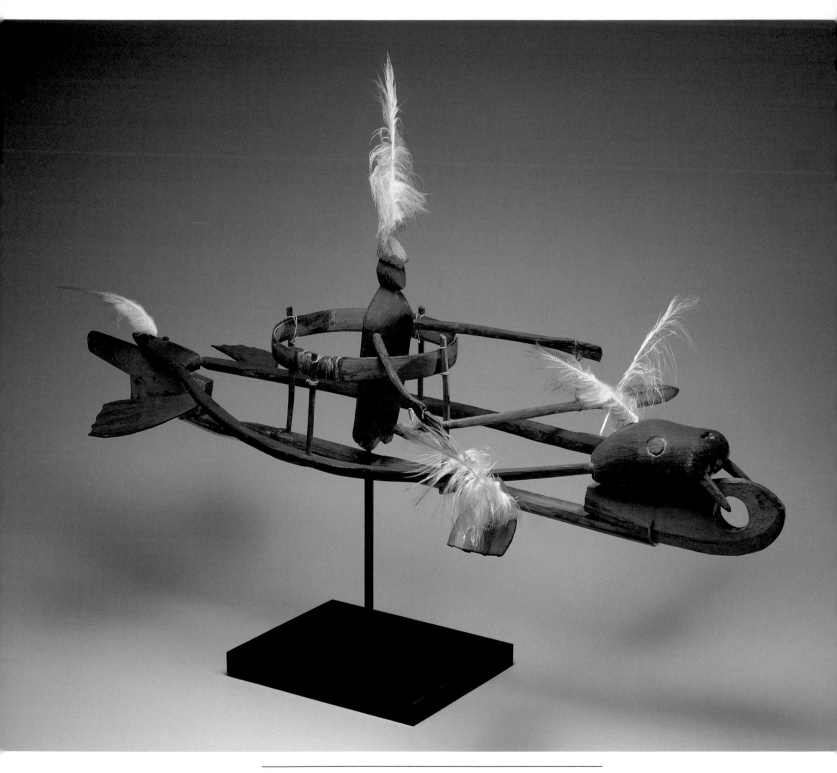

119. Ceremonial dance ornament, early 1900s

Arctic, Yup'ik Eskimo
Wood, pigment, feather; 10½ × 36⅛ in. (26.8 × 91.8 cm)
Published: Sotheby's (New York), October 21, 1994, lot 228 and
cover ill.; Fienup-Riordan 1996, pl. 254
Ex coll.: Collected by A. H. Twitchell along the Kuskokwim River,
early 1900s; Museum of the American Indian, Heye Foundation,
New York, N.Y., no. 9/3445; Stanley Grant, New York, N.Y.

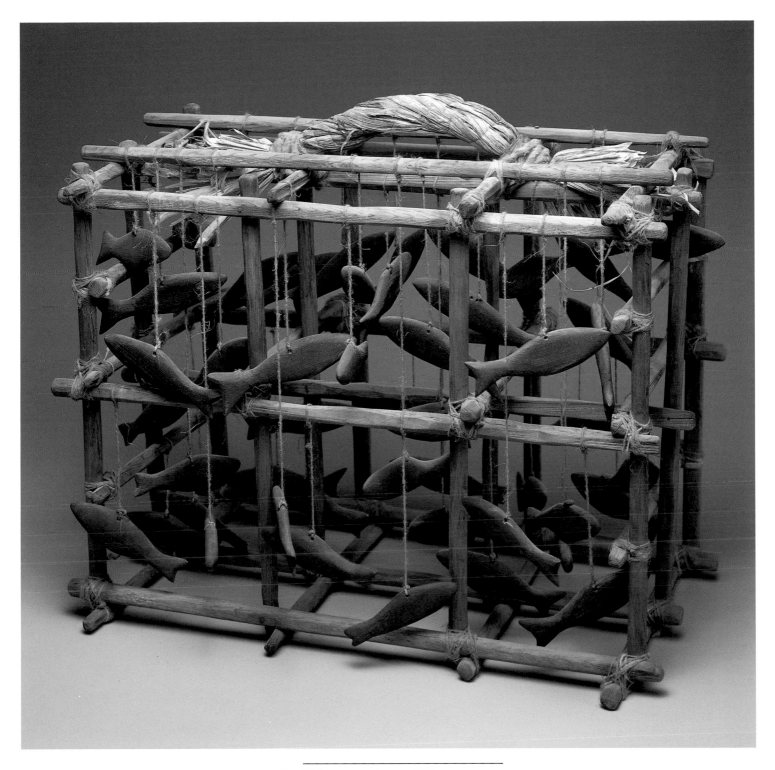

120. **Fish-trap rattle, ca. 1910**

Pacific Northwest, Nuu-Chah-Nulth
Wood, paint, plant fiber; 14⅛ × 17½ in.
(35.9 × 44.3 cm)

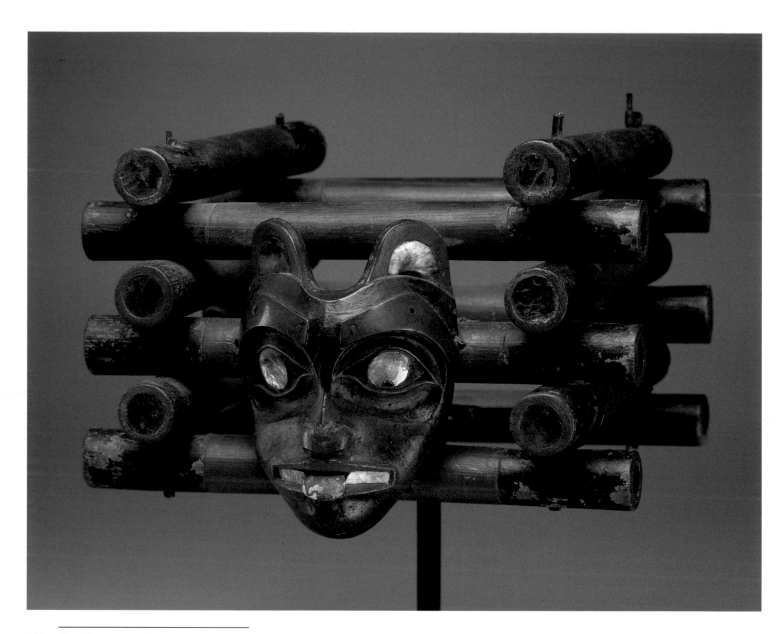

121. Frontlet, ca. 1860

Pacific Northwest, Tlingit
Wood, paint, shell inlay; 5 × 8⅛ in.
(12.8 × 20.7 cm)

122. Frontlet, ca. 1870

Pacific Northwest, Haida
Wood, paint; 7¼ × 6 in. (18.4 ×
15.2 cm)
Ex coll.: Les Brendible, Jr.,
Ketchikan, Alaska

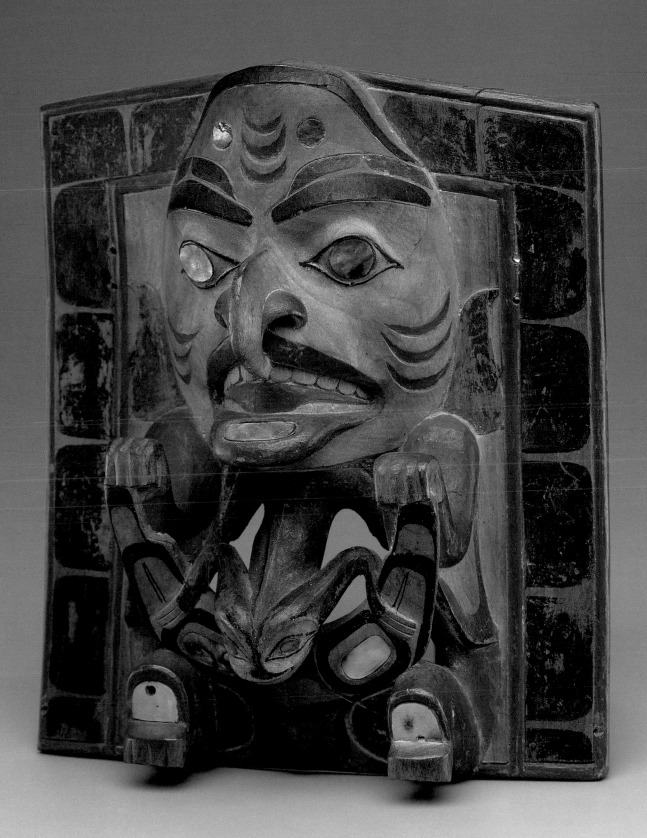

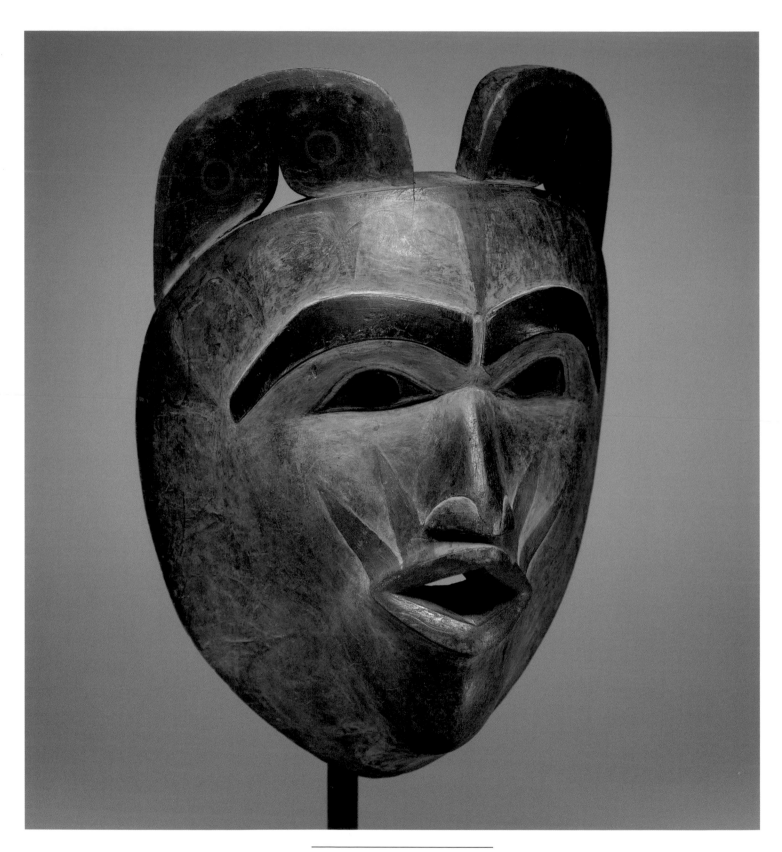

123. Bear mask, ca. 1850

Pacific Northwest, Tlingit
Wood, paint; 10⅜ × 7¼ in. (26.5 ×
18.5 cm)
Published: Christie's (London),
June 29, 1983, lot 105

124. Raven rattle, ca. 1850

Pacific Northwest, Tlingit
Wood, paint; 4¾ × 13¾ in. (12 × 35 cm)

125. Bird rattle, ca. 1840

Pacific Northwest, Tlingit
Wood, paint; 4¾ × 8½ in. (12 × 21.7 cm)

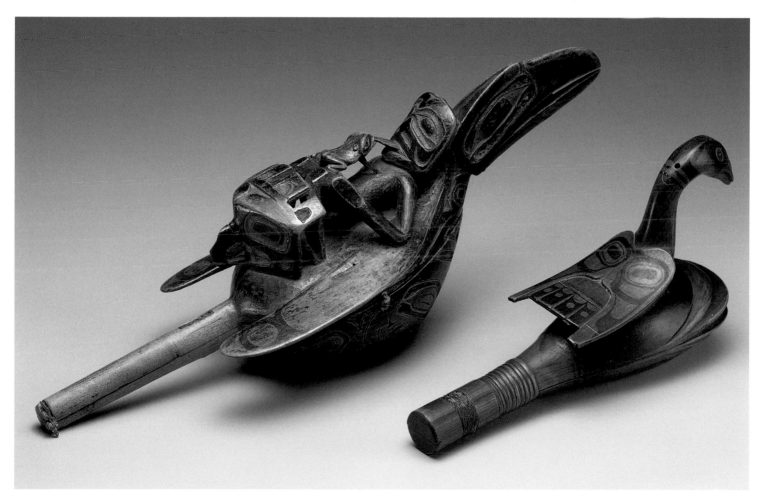

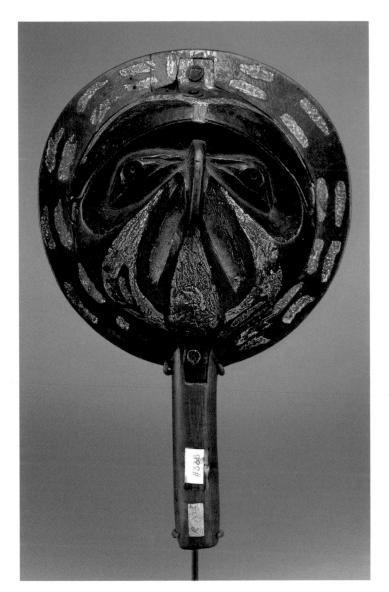 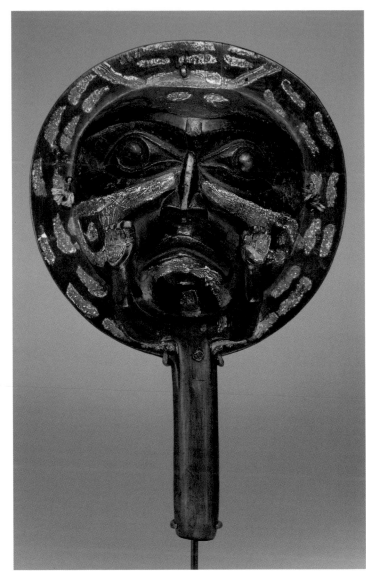

126. Rattle, ca. 1850 (2 views)

Pacific Northwest, Bella Bella
Wood, paint; 8⅜ × 5⅜ in.
(21.3 × 13.8 cm)

127. Child's tunic, ca. 1870

Pacific Northwest, Haida
Native-tanned skin, pigment, ribbon; 42½ × 31⅝ in. (108 × 80.3 cm)

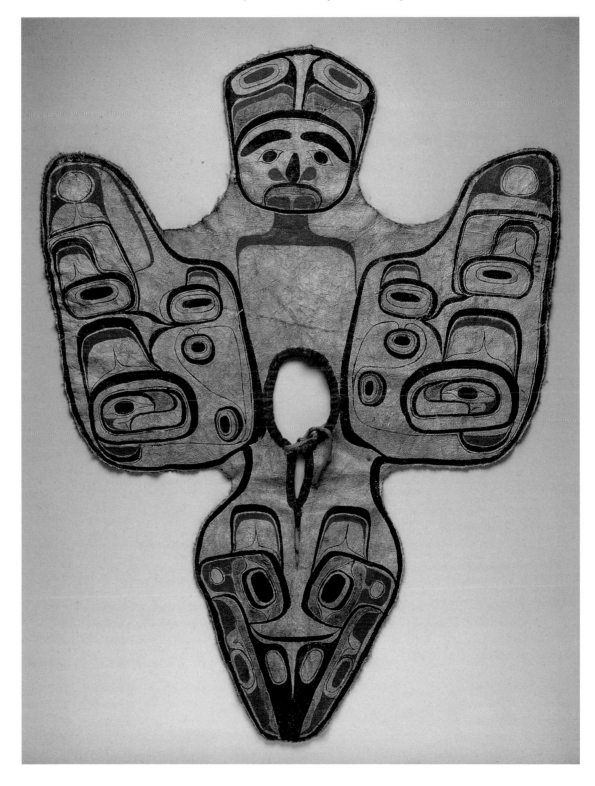

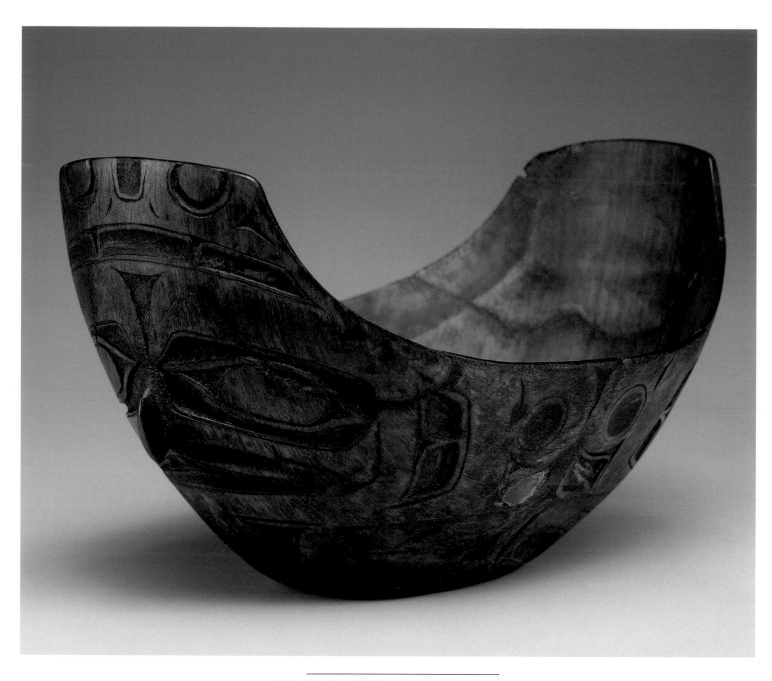

128. Bowl, ca. 1830

Pacific Northwest, Haida
Horn; 8¼ × 5⅜ in. (21 × 13.5 cm)
Ex coll.: Taylor Museum, Colorado
Springs, Colo., no. 4977

129. Soul catcher, ca. 1850

Pacific Northwest, Tsimshian
Bone, shell inlay; 1½ × 7½ in. (3.8 × 19 cm)
Ex coll.: Stanley Grant, New York, N.Y.

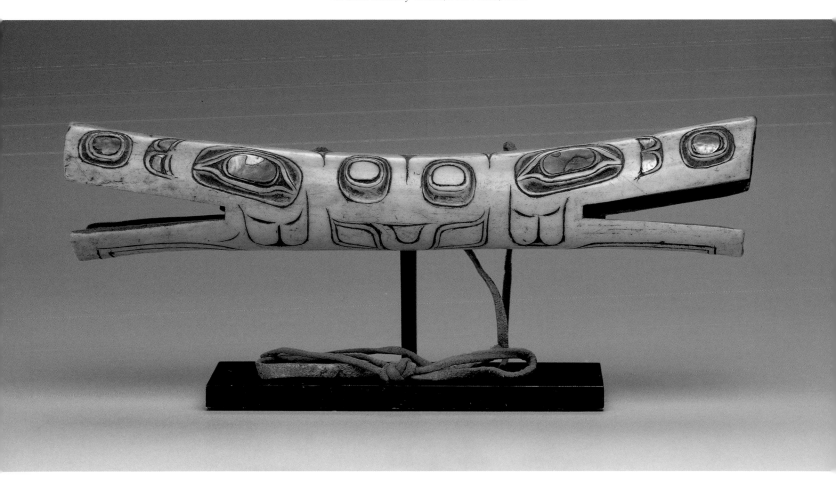

130. Shaman's amulet, ca. 1830

Pacific Northwest, Tlingit
Antler; 1¾ × 5¼ in. (4.5 × 13.5 cm)
Published: Barbeau 1953, p. 270,
fig. 232
Ex coll.: Axel Rasmussen, Wrangell,
Alaska; Marius Barbeau, Ottawa,
Ontario, 1939

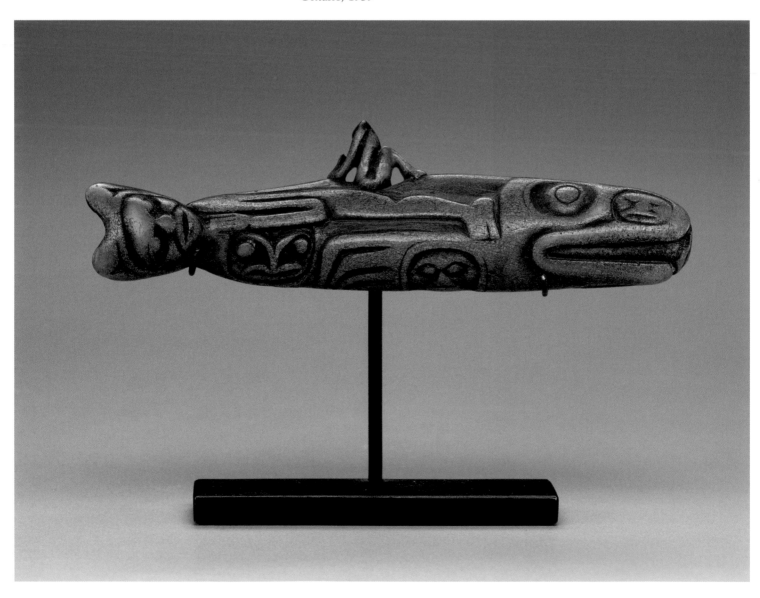

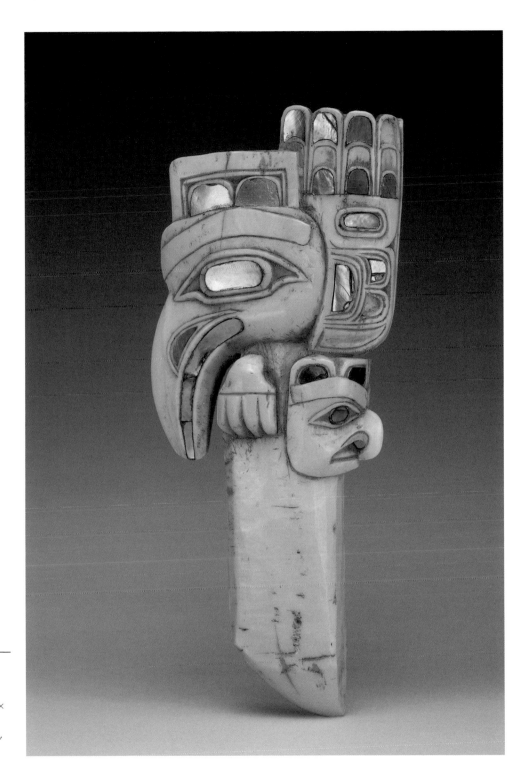

131. **Finial or down cup, ca. 1840**

Pacific Northwest, Haida
Whale-tooth ivory, shell inlay; 6⅛ ×
2½ in. (15.7 × 6.3 cm)
Ex coll.: Harry Beasley, Chislehurst,
England

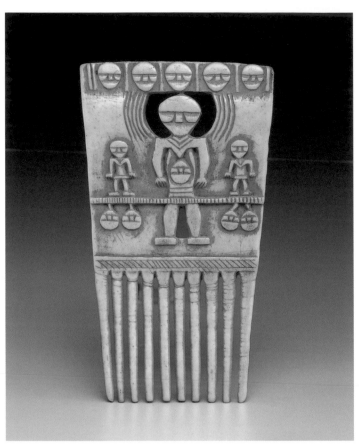

132. Comb, ca. 1820

Pacific Northwest, Salish
Bone; 4¾ × 2¾ in. (12 × 7 cm)
Published: Christie's (London), June 17, 1980, lot 3; Christie's (London), June 24, 1996, lot 175
Ex coll.: James Hooper, London, England

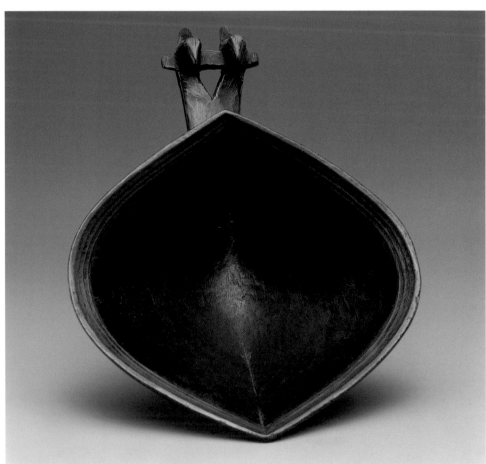

133. Ladle, ca. 1850

Pacific Northwest, Chinook
Wood; 8¼ × 6 in. (21 × 15.2 cm)
Ex coll.: Bud Wellman, Boston, Mass.

134. Figure, 1700s

Pacific Northwest, Wishram
Bone; 10⅛ × 3 in. (25.9 × 7.6 cm)
Published: Coe 1977, no. 46
Ex coll.: Said to have been found at
the mouth of the Umatilla River
near the juncture with the Columbia
River, Ore.

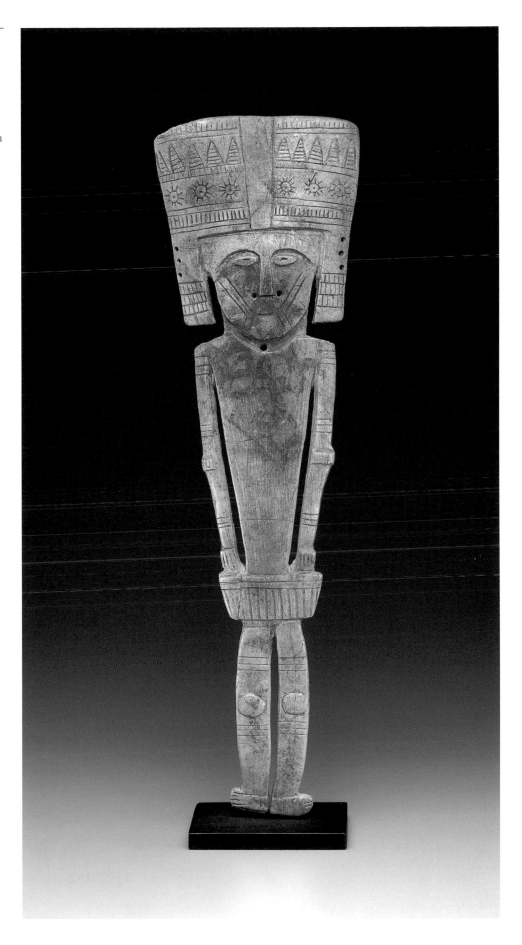

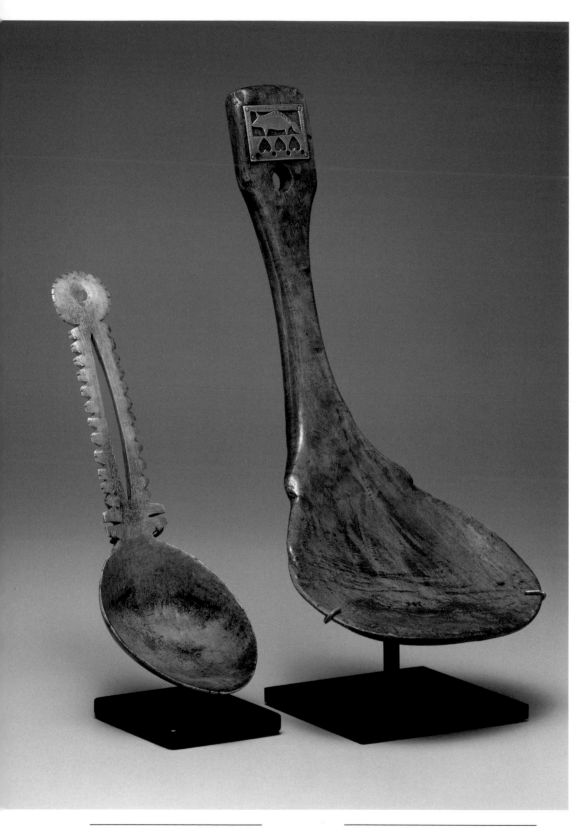

135. **Spoon, ca. 1880**

Northern California, Hupa
Horn; 7¾ × 2⅜ in. (19.8 × 6 cm)

136. **Ladle, ca. 1850**

Eastern Woodlands, Menomini
Wood, silver; 9⅝ × 4⅛ in. (24.5 ×
10.5 cm)

137. Spoon, ca. 1840

Pacific Northwest, Tlingit
Horn, shell inlay; 13⅛ × 2⅜ in.
(33.5 × 6.2 cm)

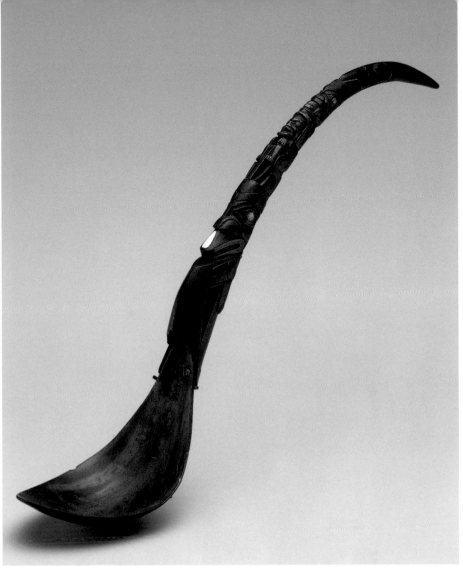

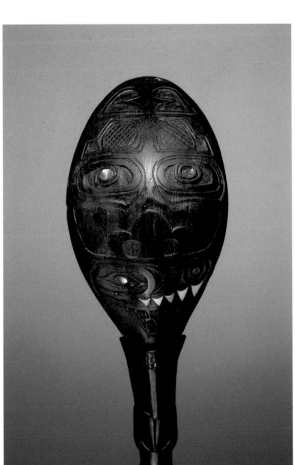

Detail of cat. no. 137

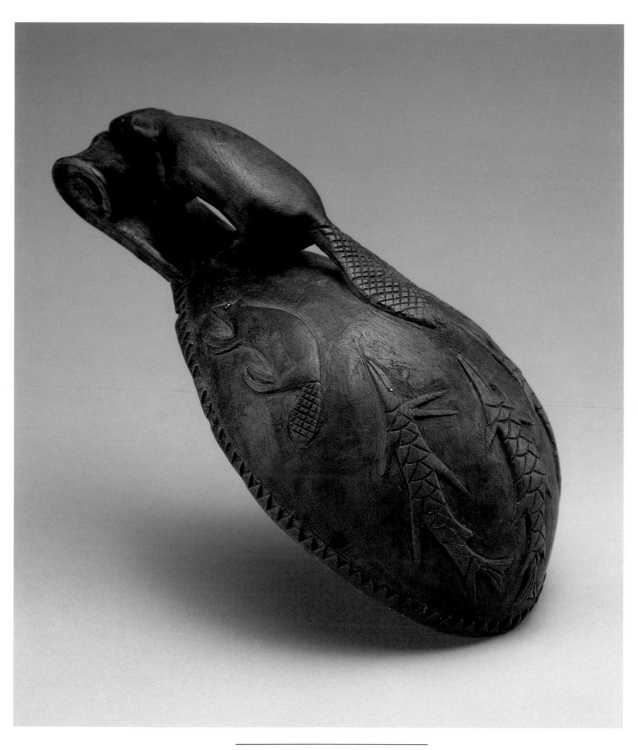

138. **Belt-cup, 1800s**

Eastern Woodlands, Penobscot (?)
Wood; 5⅞ × 3⅛ in. (15 × 8 cm)

139. Pipe bowl, ca. 1780

Eastern Woodlands, Central Algonkian
Wood, brass, tin; 3½ × 6 in. (8.8 ×
15.3 cm)
Published: Phillips (London), July 3,
1995, lot 183; Christie's (Los
Angeles), November 6, 1997, lot 143

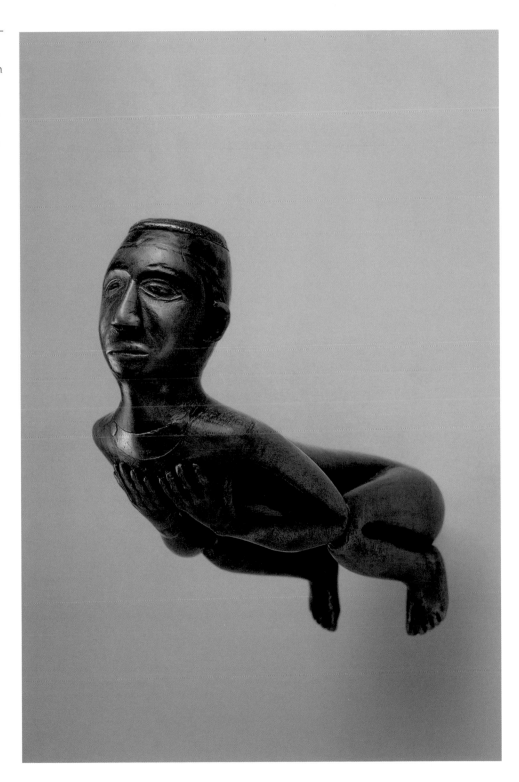

Bibliography

Barbeau, Marius
1953 *Haida Myths Illustrated in Argillite Carvings*. Bulletin 127. Ottawa: National Museum of Canada.

Bates, Craig
1979 "Miwok-Paiute Basketry 1920–1929: Genesis of an Art Form." *American Indian Art Magazine* 4 (4): 54–59.

Bates, Craig, and Martha J. Lee
1990 *Tradition and Innovation: A Basket History of the Indians of the Yosemite–Mono Lake Area*. Yosemite National Park, Calif.: Yosemite Association.

1982 "Ethnographic Collections at Yosemite National Park." *American Indian Art Magazine* 7 (3): 28–35.

Berlo, Janet
1996 *Plains Indians Drawings 1865–1935: Pages from a Visual History*. New York: Harry N. Abrams.

Coe, Ralph T.
1977 *Sacred Circles: Two Thousand Years of North American Indian Art*. London: Arts Council of Great Britain / Kansas City: Nelson Gallery Foundation.

Cohodas, Marvin
1976 "Dat So La Lee's Basketry Design." *American Indian Art Magazine* 1 (4): 22–31.

Curtis, Natalie
1907 *The Indians' Book*. New York and London: Harper and Brothers.

Ewers, John C.
1986 *Plains Indian Sculpture*. Washington, D.C.: Smithsonian Institution.

Feder, Norman
1971 *American Indian Art*. New York: Harry N. Abrams.

Fienup-Riordan, Ann
1996 *The Living Tradition of Yup'ik Masks*. Seattle: University of Washington Press.

Frank, Larry, and Frances Harlow
1974 *Historical Pottery of the Pueblo Indians*. Boston: New York Graphic Society.

Hewitt, J. N. B.
1937 "The Journal of Rudolf Friederich Kurz." *Bureau of American Ethnology Bulletin* 115 (Washington, D.C.: Smithsonian Institution).

Holm, Bill
1981 "Crow–Nez Perce Otterskin, Bowcase Quivers." *American Indian Art Magazine* 6 (4): 60–74.

Maurer, Evan
1977 *The Native American Heritage*. Chicago: The Art Institute of Chicago.

1992 *Visions of the People: A Pictorial History of Plains Indian Life*. Minneapolis: Minneapolis Institute of Art.

McCoy, Ronald
1987 *Kiowa Memories, Images from Indian Territory, 1880*. Santa Fe, N.M.: Morning Star Gallery.

1992 "Short Bull: Lakota Visionary, Historian, and Artist." *American Indian Art Magazine* 17 (3): 54–65.

1994 "Swift Dog: Hunkpapa Warrior, Artist and Historian." *American Indian Art Magazine* 19 (3): 68–75.

Miles, Charles
1963 *Indian and Eskimo Artifacts of North America*. New York: Bonanza Books.

Penney, David, et al.
1983 *Forest, Prairie and Plains: Native American Indian Art from the Chandler–Pohrt Collection*. Detroit: The Detroit Institute of Arts.

Peterson, Karen Daniels
1988 *American Pictographic Images: Historical Works on Paper by the Plains Indians*. New York: Alexander Gallery and Morning Star Gallery.

Phelps, Steven
1976 *Art and Artifacts of the Pacific, Africa and the Americas: The James Hooper Collection*. London: Hutchinson and Company.

Szabo, Joyce
1992 "Howling Wolf: An Autobiography of a Plains Warrior-Artist." *Allen Memorial Art Museum Bulletin* 46 (1): 4–87.

1994 *Howling Wolf and the History of Ledger Art*. Albuquerque: University of New Mexico Press.

Wooley, David, ed.
1990 *Eye of the Angel: Selections from the Derby Collection*. Northampton, Mass.: White Star Press.

Index

Page numbers in *italics* refer to illustrations. Catalogue numbers are preceded by "No." or "Nos."